Magic Realist Watercolor Painting

Magic Realist Watercolor Painting

BY RUDY DE REYNA

WATSON-GUPTILL PUBLICATIONS/NEW YORK
PITMAN PUBLISHING/LONDON

First published 1978 in the United States and Canada by Watson-Guptill Publications,
a division of Billboard Publications, Inc.,
1515 Broadway, New York, N.Y. 10036

Published in Great Britain by Pitman Publishing Ltd.,
39 Parker Street, London WC2B 5PB
ISBN 273-01285-1

Library of Congress Cataloging in Publication Data
De Reyna,Rudy, 1914-
　　Magic realist watercolor painting.
　　Bibliography: p.
　　Includes index.
　　1. Water-color painting—Technique. 2. Magic
realism (Art). I. Title.
ND2422.D46　　751.4'22　　78-8194
ISBN 0-8230-2957-3

Manufactured in Japan

First Printing, 1978

For Jeanne

ACKNOWLEDGMENTS

Because no book is ever a one-man job,
I'm deeply indebted to Donna Wilkinson
for polishing the word, to Bob Fillie
for designing the work, and to Don Holden
and Marsha Melnick for guiding the author.

Rudy de Reyna
East Sandwich, Massachusetts

Contents

Introduction

It was a time when the watercolor box was cheek by jowl with the embroidery needles and French grammar that rounded a young lady's crowning achievements. It was a time when watercolor was a plaything, too dainty and fragile to convey the deeper and nobler concepts of the serious painter. It was a time when a picture not anointed by the Royal Academy was summarily dismissed as unworthy of its hallowed halls; and watercolors, falling into this ignominious category, went begging for a place to hang. But by George it was also a time when men like Cozens and Girtin and Turner turned to it and made it say moving and eloquent things. For their steadfastness in the face of blind opposition, for their fluent and brilliant execution, and for the innovations that we still practice today, we who manipulate watercolor will always be grateful. I'm also thinking of Cox, Rowlandson, Bonington, Cotman, and Flint, and I cannot list them all. I'm not unaware of German, French, Russian, and Italian contributions to the medium. But it was Cozens who first rubbed and washed a picture to get distance and atmosphere; and Turner and Girtin who are given credit for being the first to wipe out the lights. If today we're not qualmish about combining charcoal, pastel, pencil, and body color with aquarelle, it is because that happy breed of men have shown us the way.

Now with this heritage as the point of departure let's explore new ways with watercolor. We shall begin by discussing the proven and traditional watercolor methods. We shall also look into the things the medium can do when aided and supported by the modern technology that has given us acrylic paints, artificial sponges, masking cements, and synthetic fiber brushes. As we tackle each picture I'll not only comment on the mechanics of the craft but will also tell you what motivated me to paint. I shall be open and candid and withhold nothing. When my reference material happens to be a study or a sketch done from nature, I shall tell you. If my data happen to be photographic, or a combination of sketches and snapshots, I will unabashedly tell you because I firmly believe the painter's duty is to make the statement as forceful as possible with all available means. There was a time when artists feared that the camera would replace them. That's understandable, but nothing can possibly replace the soul and that's our one indispensable tool—because without it the most flawless technique will say nothing. The gift you've been given is a blessing, but it is also a sacred trust that has great responsibilities: to nurture it and to make it grow. It's my job to guide you as best I can and that's the sole purpose of this book. The artist setting out on the road to painting should be well equipped to face fair or foul weather. Yes, there will be rough stretches and not every day will be sunny, but after all if it were a picnic everybody would join us. So it would be wise to prepare yourself for whatever hazards may lie ahead. Even though Art, being a law unto itself, will not be chained to any set of rules, there's a certain discipline it imposes upon us all: It is

only through constant application that we learn to speak visually. Aptitude no matter how great needs tending and mending. Contrary to popular belief, talent doesn't spring up suddenly. Consciously or not it percolates for a time before it makes itself known. The tale that Byron awoke one morning to find himself a poet is fiction; the seed had been germinating from the day he took delight in literature. Obviously you delight in painting; very well, the time has come to buckle down.

I thought it best to begin in the traditional purist manner of washes and glazes, leaving the paper itself for the whites—and that comprises the first section of the book. Then comes the investigation of opaque watercolor, in which the lights are painted over dark tones. The next section discusses painting in acrylic, which can be handled in either a transparent or opaque manner, or interchangeably. Finally, the closing chapters show how combinations of two media can be used so that one can buttress the shortcomings of the other.

Following this system, every painting was done expressly for this book. And in each one I determined that there should be some new and exciting discovery for you. The number of things to be learned will naturally depend on your status as an artist, but between the basics and the refinements I'm confident there will be something revealing and stimulating. The pictures are arranged in a sequence that progressively becomes more challenging, beginning with a simple still life of three onions. Actually every section, as we move from one medium to another, begins with an indoor still life because that's the most convenient way for you to solve technical problems. Then there are outdoor still lifes, comfortably done looking out a window or sitting in the car, and still others more enterprising that were done in an open field. Landscapes come next with a few more demands. And finally, we come to seascapes which demand a closer scrutiny of, and more sensitive reaction to that ever restless element—the sea. Some of the subject matter I have chosen may not appeal to you and that's the way it should be. You must paint only the things you find exciting. If motorcycles leave you indifferent, then substitute them with bicycles or even the baby's tricycle or whatever would put to use the things taught in the demonstration.

It is my hope that you paint along with me because an artist develops not by being told but by doing. I can tell you how a brush responds, a paper reacts, or a pigment behaves, but you'd be gaining only information and not the *knowledge and experience that is acquired only by doing*. Perhaps I shouldn't be so vehement. I'm sure you need no urging or you wouldn't be reading this. Very well, if your desire is to learn, mine is to teach and may a kind Providence grant us both our wishes.

Materials and Equipment

TRANSPARENT WATERCOLOR

Watercolor, as the name attests, is pigment soluble in water with a binding vehicle that allows the color to be thinned to the most watery dilutions without weakening the adhesive power. It is formulated so that one glaze can be applied over another without disturbing the first, and there lies the medium's greatest charm. The subtle nuances, the vibrancy, and luminosity are obtained by letting underlying tints be seen through subsequent shades of color.

My favorite brands are the tube colors by Winsor & Newton for larger works, and the Grumbacher No 30/17 Symphonic set for small paintings. For rough compositional sketches and other behind-the-scenes work where permanence and brilliance are not essential I turn to Grumbacher's Academy watercolors. The student would do well to also use them for practice work and exercises.

The realistic way of painting I pursue made it necessary for me to bridle the natural exuberance and spontaneity of the medium. Not because I delight in suppressing its intrinsic tendencies but rather that the thunder and lightning of swish and dash, lovely and exciting as it is, does not lend itself to the representation of things as they are.

Brushes. "Blast the confounded brush!" is the exasperated cry of most students, and justifiably so, because the brushes their puny purses can afford are an insult to that vital tool.

The sable brush, pointed and flat, has been the workhorse of watercolor painting for hundreds of years. Unfortunately, they have become so beastly expensive that the larger sizes are bordering on the prohibitive, and I wish to heaven they weren't indispensable to professional work. But there's a bright note in all this. Robert Simmons has recently given us White Sable, an excellent synthetic fiber that behaves extraordinarily like the traditional sable hair.

It's the lot of the painter to work with the head, the soul, and the hand. In that context we can say that the brush is an extension of the arm, and all kinds of brushes—bristle, nylon, stippling, and even toothbrushes—can play a role in the execution of transparent watercolor.

Other Tools. Even though the artist can use the brush alone to depict anything he wishes, there are times when it's wise to resort to other tools to enhance an effect, to accentuate certain characteristics, and to expedite things that would otherwise require painstaking and time-consuming rendering. The other tools I use in the execution of aquarelle include a single-edge razor blade, masking liquid, a white Stabilo pencil, paper towels, and a kneaded rubber eraser.

Palettes. The reason that some resourceful watercolorist picked up a butcher's tray to mix colors is that the average palette might be perfect for the miniaturist, but leaves the painter clamoring for more space. It's a good idea to have three or four butcher's trays in various sizes and ready for action because dried up mixtures of transparent watercolor get unpleasantly gritty when wet again. I prefer the larger sizes because it's more convenient to have the nesting cups, the slant-and-well palette, or the color box itself right on the tray for quick color pickup. There are times when even a goodly supply of trays is exhausted, but instead of wiping off a mixture that might be needed later, I raid the kitchen for cups and white dinner plates.

Painting Surfaces. Would it be redundant to say that the best painting surface for watercolor is watercolor paper? Sorry, but that's the way it is. Whether in single sheets, in blocks or pads, or as surface papers mounted on backing boards, it's the acknowledged support for the medium. And of all the brands I've used in over half a century of painting I find myself returning time and again to Crescent No. 112, Strathmore, Bainbridge No. 80, Fabriano, and d'Arches. Try them, if you haven't, for your significant work and get cheaper papers for your lesser efforts.

At the risk of courting redundancy again, I must mention that the only thinning agent I use for all water-based paints is water.

OPAQUE WATERCOLOR

Even though opaque watercolor can be diluted to a watery consistency it would be rash to attempt glazing one color over another in the hope of intensifying or neutralizing an undertone. This is the domain of transparent watercolor, not to be usurped by a semiopaque and opaque medium. Watery opaques, however, can be used for the broad and simple lay-in that can be the foundation for the painting as it progresses to the finish.

It has always puzzled me that students have no trouble at all in diluting transparent watercolor properly but find themselves at sixes and sevens when thinning opaques. Generally, the paint is left much too thick for the manipulation necessary to render realistic work. I think the best suggestion I can make is that it should be thinned far more than you imagine. Try it this way. Paint a dark shape and then when dry, execute some light linear and tonal figures on it. If the lighter value covers the darker value, the consistency is correct; if not, simply add more paint. I dwell on this and explain even the obvious because the right consistency is extremely important for the rendering of minute detail, which is the hallmark of the opaques. But every medium has its concessions as well as its cussedness. If opaques lend themselves to explicitness, they also have the nasty habit of changing value after drying. Or perhaps I'm exaggerating this particular shortcoming. To compensate for this value change, test the color on the margin of the picture to see what happens when it dries. Even though there are many quality brands on the market, I have a definite preference for the smoothness, the brilliance, and covering power of Winsor & Newton's Designers Gouache. Another choice for small paintings in the studio and for sketching outdoors is the Pelikan 735 E/24 metal box of 24 colors. The cakes soften quickly when moistened, the color is picked up easily, and the brush is spared the rubbing required by some of the other sets. And since my way of working calls for the side of the brush as much as for the tip, I want to save whatever rubbing that has to be done for the actual painting.

Brushes. It certainly is a comfort to know that the brushes congenial to transparent watercolor can be just as chummy with opaques and perform in the same bouncy and spirited manner. I feel I should mention this even though most artists know that any brush working with one aqueous medium will feel at home with another of the same kin. There was a time when it was thought that opaque color was injurious to sable, just as today it is believed by some that acrylic is the archenemy of all brushes. Poppycock and balderdash and stuff and nonsense and all sorts of protestations like that. It is a fact that the source of these lamentations is the artist who neglects and abuses his tools. All brushes, on leaving the shop where they were cuddled and lovingly kept from harm, are entrusted to our care; all they ask is for a good bath at the end of a good day's work. If cleanliness of the human frame is next to godliness, then cleanliness of the brush is indeed next to wisdom.

Other Tools. On the premise that I consider extra tools anything beyond the three essentials of paint, paper, and brushes, I shall say that in the execution of the paintings in opaque I needed further assistance from a mat knife, a painting knife, typewriter paper, and matte fixative.

Palettes. Just as I use the same brushes for transparent watercolors as I do opaque watercolors, so do I mix the stuff on the same butcher's tray. But let me for a moment assume that a butcher's tray is not available in your area, and that the art materials catalog hasn't arrived yet. Very well, temporary substitutions can range from a piece of glass with a white paper backing taped to it, a white panel from a discarded fridge or stove, a piece of white formica, or a piece of Masonite that you yourself can enamel. I never saw a skinned cat and I hope to heaven I never see one, but I understand there's more than one way to do it.

Painting Surfaces. The most universally accepted support for opaque watercolor is illustration board, and for very good reasons. The surface papers range from rough to smooth, and the backing boards can be either thin for the smaller works, or thick for the larger and more ambitious attempts so that in either case the board will not buckle even after repeated wettings. The materials for transparent and opaque colors are so interchangeable that papers for aquarelle are just as suitable for opaques. As transparent color takes advantage of underlying washes for the liveliness of superimposed glazes, so can opaque get the most of colored grounds by letting them show through. Gray and tinted mat boards can be successfully used when care is taken to select the right tint or shade that will harmonize with the overall color scheme of the picture.

ACRYLIC

Paint chemistry's newest gift to the artist is acrylic, that great mimic that can masquerade as an aquarelle, an oil painting, or as a picture in opaque watercolor. Devotees of the medium claim that within the decade we shall use nothing but acrylic in our work. The exaggeration is understandable, following the logic that if one medium can satisfy the watercolorist as well as the painter in oils, why bother with any of the others? Persuasive reasoning, but erroneous in that we don't switch to different media simply for the label. We use it for its character, handling, and virtues so that it will enhance the results and facilitate the execution of a particular piece of work. I'm not demeaning its qualities, the stuff is marvelous and I love it. I'm simply pointing out that in my opinion different subjects call for different media, and the painter should be conversant with as many as possible. We must not forget that a watercolorist as great as Winslow Homer found it necessary at times to change to oil (and back again) because there are things better said in one medium than another. Just like transparent and opaque watercolor, acrylic is diluted with water, but it can also be thinned with special mediums to make the work glossy or semi-matte. Try these things. I did, but found that I prefer plain water as the thinning agent.

Brushes. I reach for whatever brush is capable of giving me the effect I want. A system I have evolved when working in acrylic is to separate only those brushes I use during a painting session so that I can be sure which ones to wash thoroughly (with warm water and Ivory or Pears soap) at the end of the day. Another word of caution, in an effort to keep the brushes wet while working, please do not leave them in the water jar standing on their heads. After a time the hair will bend and stay that way. Besides, water-soaked handles expand and after drying the ferrule becomes loose. Why invite unpleasantness when our job is demanding enough under ideal conditions? While working I keep my brushes moist by laying them flat in a tipped butcher's tray with just enough water to cover the stock, while the handle rests on the rim.

Other Tools. Aside from the unorthodox tools employed with the previous media, I used an expired credit card, Liquitex gesso, a sponge, and a Pink Pearl eraser as extra tools for the acrylic paintings. When I put another tool to work it's because I expect it to give me better results than the brush. By the same token I'd like you to prod your own resourcefulness and consider common objects—from toothpicks to matchboxes as potential painting tools.

Palettes. If variety is the spice I'm afraid the palette assortment has been awfully bland, but after all, one uses the most convenient and if butcher's trays meet our requirements, why change? I've tried the peel-off paper palettes to avoid constant cleaning of the tray, but the blinking things cockle and crinkle when used for any of the water-based media. On the other hand, I think it's the best when working in oils—but that's another story.

Painting Surfaces. A plaster wall, paper, acetate, metal, illustration board, gesso panel, cloth, canvas, plywood—you name it, and that can be a support for acrylic. No doubt it's one of the reasons the medium's votaries swear that there's no better. Well and good. After all, an artist communicates by whatever means are the most satisfactory and fulfilling.

Evident as it is, I feel compelled to say that the brushes, palettes, and painting surfaces put to work for the execution of the transparent, opaque, and acrylic paintings were also used for the pictures done in the combinations of transparent and opaque, and transparent and acrylic.

It remains for me only to mention the extra tools I used for the work done in the last classifications: India ink, Gillott pen point 404, graphite stick, T-square and triangle, ball-point pen, HB and 2H pencils. It's understood that you already have a drawing table or drawing boards and tabouret, water jars, rulers, tape dispensers, and all the paraphernalia an artist accumulates from the moment a brush or a pencil is picked up.

Preliminary Exercises

"Tell me where is fancy bred, in the heart or in the head?" How should I know, if Willy himself was not sure. But wherever it breeds it must be kept bright-eyed and bushy-tailed with daily infusions of nature's wonders, a grain of reverence, and a dram of contemplation. I believe it's when the artist stands before nature that something begins to stir, and the prosaic becomes poetical; and fragmentary, half-realized images taunt him and tease him and then haunt him until they're made manifest by his brush. This is the artist's visual testament born of his fancies and his visions—but there's the rub. He must try to pin down the ephemeral and the visionary into a tangible means of communication so that he can share his exultation with the rest of mankind. It's then that the picture is painted, and this brings me to the point. If the seasoned artist struggles with the transition between inspiration and presentation, how much more difficult it must be for the fledgling to cross that bridge without the proficiency in craftsmanship that such an undertaking requires. Therefore, I propose that the following exercises be diligently done before facing the challenge of the paintings that lie ahead. It has always been my belief that as the actor prepares before going on stage, and the musician checks the score before a performance, so should the painter tune up his tools before tackling the technical problems of a picture. Not knowing the extent of your ability, you alone are qualified to select the exercises that you consider to be the most profitable. But whichever they are, relax and enjoy them. There's nothing grim about the learning process. On the contrary, learning should be a joyous experience, because the breathless anticipation of discovery, the excitement of exploration, and the thrill of mastering the craft are too soon over. In a twinkling, all matters of technique become second nature and relegated to the subconscious, where they belong. Actually that's the purpose—the artist is then free to concentrate on the far more important matter of giving substance to his work instead of worrying about the execution of the components. But remember, fluent and polished rendering helps lift your work to a higher plane of sensitivity; feeling and precision are not incompatible. No one denies that there have been significant artists who were not technically skilled and countless virtuosos who never had anything to say. But I'm convinced that the greater the proficiency in the craft the better the chance to express oneself convincingly. And heaven knows that's enough of a preamble.

Before getting into the nitty-gritty, let me mention some particulars: I used Grumbacher's Finest watercolor lamp black diluted in a cup to a dark gray. It's better to work small when practicing; mine are 2½″ x 2½″ (6.4 cm x 6.4 cm) in the original, done with Nos. 5, 7, and 9 pointed brushes. Use a brand new single-edge razor blade and a painting knife. Mind the tilt of the surface, depending on whether the wash should glide or not. Use only watercolor paper or illustration board—scraps will do nicely. When doing the exercises prior to the actual painting, use the same board or paper you will use for the finished painting, since it's understood that color behaves differently on different surfaces.

Flat Wash. Generously load a No. 9 sable brush with transparent watercolor. From the top edge, float the wash down evenly in horizontal back-and-forth strokes without lifting the brush. The board should be at a slight angle, higher at the top.

Graded Wash. Wet the light area with clear water. Charge the brush generously. Begin to paint at the top and with back-and-forth horizontal strokes let the pigment float and expand into the wet area. Add water gradually to lighten the wash. If the color crawls too much into the light, quickly wipe it off with a clean damp brush.

Wet Lift-off. Paint a dark gray shape and then while still wet lift-off shapes with a damp brush; rinse it and wipe it and continue the procedure before the shape dries.

Dry Lift-off. Paint a dark gray shape and let it dry. Load a bristle brush with clear water and twirl it on the spot to be lifted off. Let the water remain a moment. Then, with a tissue or folded paper towel press down on it. The more you repeat the operation the lighter the spot will be, but be sure to mop up after each wetting.

Scratching. When the dark gray shape is completely dry, draw whatever figures you wish using the corner and the edge of a razor blade.

Painting Knife. Spread opaque paint with the flat and the edge of the painting knife. It can either be light on dark, or dark on light.

Sponging. Dip part of a sponge into the dark gray, tap it on the butcher's tray, then tap it on dry paper to make a damp light gray shape.

Drybrushing. Load a pointed brush scantily and then discharge the paint by pulling it against the rim of a cup. Then, "fan" the brush on a paper towel. Swinging from the elbow, make sweeping strokes by dragging the side of the brush across the paper in a left-to-right motion. As the brush begins to exhaust its supply of paint, reload and "empty" it and continue the quick, light strokes with the broad side of the brush.

Spattering. Dip toothbrush bristles in the gray, tap them on the tray, then rub the bristles on the edge of a piece of cardboard from left to right, about 4″ (10.2 cm) from the paper.

Masking. Brush in shapes with Luma Liquid Mask and let them dry completely. Apply tone over the area and let it dry. Use a rubber cement pickup, or if one isn't among your supplies, rub your fingers on the masking, and a little bead will form. Continue to use it, and shortly it will become big enough to let you remove the rest of the stuff with ease. Read the instructions carefully With an old brush, apply the masking within the contours of the shapes and over the drawn lines. If the shapes are small fill them in completely. As the masking begins to harden on the brush, rinse it immediately.

Ruling Method. Hold the bottom end of a ruler with your left hand and rest both hand and ruler firmly on the paper. The ruler is in a vertical position and its thin edge is facing right. Pick up some color and shape the brush to its point on the butcher's tray. Now rest the middle finger against the ruler's edge and with the hand resting on the surface, glide down applying even pressure on the brush. For horizontal or diagonal lines, turn the paper— or ruler, whichever is easier.

Wet-in-wet. Wet a shape with clear water, dip a brush into the gray, and paint some shapes onto the wet surface, taking care to leave some of the paper untouched.

DEMONSTRATIONS

1

Three Onions

Subject. I've chosen this invitingly simple subject of three onions to buttress your confidence, should it be wobbly, to entice you to begin painting straightaway, and also to show you that even the most basic handling of transparent watercolor can achieve an impressive realism. You can, if you wish, copy these onions if only to increase your skill in the medium, but I'd rather you set up a different arrangement so that you can lay claim to your own creation. It doesn't even have to be the same subject; it can range from a pair of old shoes to a head of lettuce, or whatever else you may find appealing. Just be sure to use fundamental techniques: flat washes, graded washes, wiping out lights, drybrush, and scratching out lines with a razor blade.

Brushes. I'm sure that all of us instinctively reach for the brush that will help us paint a particular passage with facility and dispatch. Following that principle, I chose a Simmons No. 6 White Sable pointed brush for the initial flat and graded washes. Naturally, I was ready to pick up another size larger or smaller if the picture required it, but it turned out that I didn't need any. This was not surprising, since the size of the original was only 8″ x 10″ (20.3 cm x 25.4 cm).

Other Tools. Since it wouldn't be cricket when working in the traditional manner to introduce opaque watercolor, I resorted here to using a razor blade to scratch out the light lines of the roots. It is the only other tool I used besides the White Sable brush.

Palette. Because these onions are predominantly red-violet, it stands to reason that I used this mixture the most. However, it was tempered with the yellows, oranges, greens, and browns found in the Grumbacher Symphonic watercolor set No. 30/17.

Painting Surface. I chose a Bainbridge No. 80 cold-pressed, single thickness illustration board, because just as I pick a specific brush to do a particular job, I also select a surface that helps me easily achieve the results I seek. The eggshell surface of this board, for example, makes it easy to render the drybrush passages. It also takes flat and graded washes smoothly, and the paper is sturdy enough to withstand the punishment of the razor blade.

Medium. At the beginning of the last century, a watercolor was done with powdered pigment, a spot of glue to bind it, water to thin it, and that was all. Whoever was insolent enough to desecrate this purity was dismissed as a charlatan incapable of coping with the demands of the medium. There was no alternative but to muddle through in oils or any other less exacting medium. Though artists, free spirits that they are, do not submit for long to rules or restrictions. Today, a watercolor can be a potpourri of transparent and opaque, interlaced with crayons, inks, and pastels—seasoned with sprinklings of salt, and even battered with a few swishes of sand. And why not, if the desired results are attained? I have done this demonstration and the following three strictly in transparent watercolor, not as models of purist principles, but only to show you what the medium itself can do without the aid of other materials. Later, I will combine it with other media, but for the moment let's first wet our feet with transparent watercolor alone.

I don't think I need to say that I added only water to thin the pigment.

Painting Tips. The larger the painting the thicker the support, is a good rule to remember when working in watercolor. Anything larger than, say, 11″ x 14″ (28 cm x 36 cm) should be done on double thick boards to prevent bending and buckling. A realistic painting, unassisted by "lucky accidents," can take a day, a week, and even a month. So protect your color between sessions; in this instance by always putting the lid back on the Symphonic set. Rinse the brush well and reshape it by pulling it between your fingers to its original point. The dry color on the palette can be used the next day by spraying it with an atomizer before beginning to work—or simply by rewetting the brush with whatever color you need. If you intend to be absent longer, then I suggest you cover the entire palette with plastic film so it doesn't get dusty.

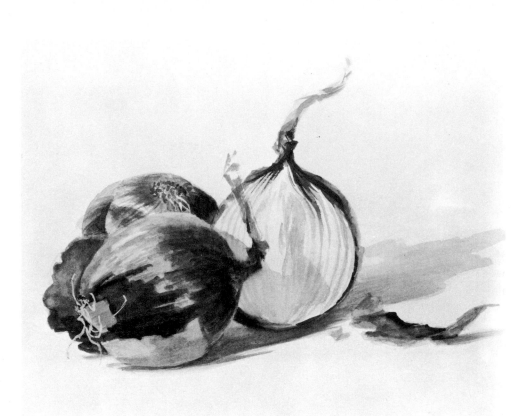

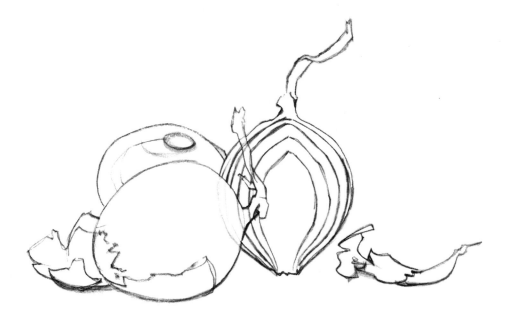

Sketch. (Top) Even though I have no fixed procedure in executing a painting, I often find myself doing a sketch first of whatever attracts me. Probably, this is because I can do it so quickly, and it gives me a chance to see whether or not the subject should be carried out to a finished painting. My sketches are usually smaller, though throughout the book they are shown the same size as Step 1.

While marketing I saw these onions, and although their color and texture were clamoring for attention, I pushed the cart past them with only a casual glance. It wasn't that I was insensitive to their beauty, but I was busy getting items on my shopping list. Soon I realized it was no use trying to ignore them. As I continued my search for the items I wanted, I could see nothing but onions. So I went back and picked up three of them. Here they are in an 8" x 10" (20.3 cm x 25.4

cm) study. I drew them lightly with a No. 2 office pencil on a Paper King pad and then dipped into the Symphonic set No. 30/17, with a No. 7 and a No. 3 brush. I mention all this because I want you to become aware of the abundance of potential subjects in a market. Next time, buy something that appeals to you and paint it.

Step 1. (Above) I thought these onions worthy of development so, placing a piece of tracing paper over the sketch, I refine the drawing with an office pencil. Then, taping the drawing at the top of the illustration board, I insert a transfer paper and trace it with a 5H pencil. When I start the painting, I consult the sketch for the better things it contains as well as consulting the actual onions set up before me.

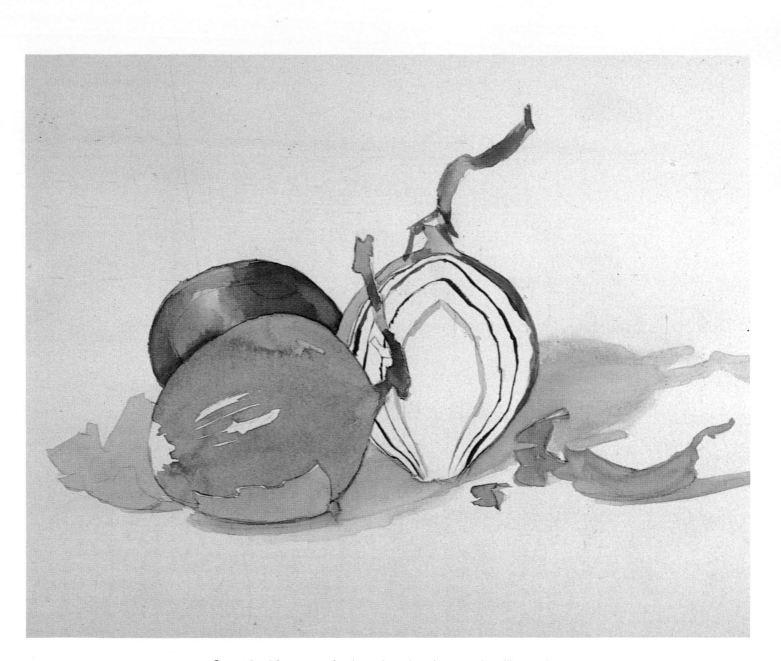

Step 2. After transferring the drawing to the illustration board, I use the No. 6 White Sable watercolor brush to float a thin flat wash of red-violet over the front onion. Notice the saved white areas that I left, which will become highlights. I move then to the cut onion and, with the tip of the brush, I indicate the contour of the bulb as well as the divisions of the core. Next, I pick up paint from the puddle in the butcher's tray, which is mostly water with a touch of red-violet from the Symphonic set. With the brush I transfer some of this puddle to another spot on the tray and add a bit of orange to it. I wet the rear left onion with clear water, and then apply the graded wash to the left side and then to the right side, letting the pigment skirt the highlight in the middle. As I do this, I tilt the illustration board to an angle that lets me control the shapes of the washes. After adding more water to the second puddle, I paint the skins falling off the front left onion, and also those on the right. Now, to do the stems I mix as I paint, as opposed to using a premixed tint, and dip into the brown light, yellow-green, and yellow ochre. Finally, after dampening the area, I do the cast shadows with blue-violet and brown dark. Throughout this book, unless I mention that I have wet or dampened the paper, I will always be working on a dry surface.

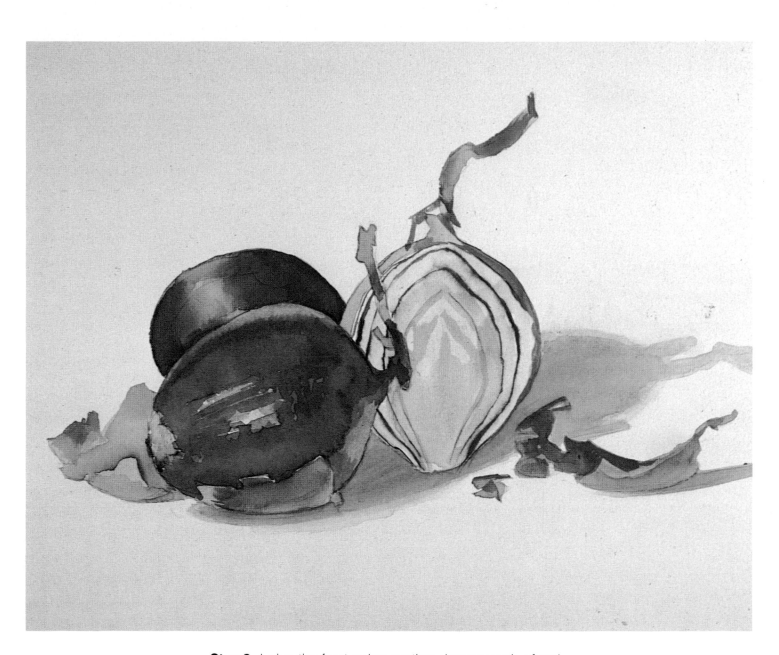

Step 3. I give the front onion another deeper wash of red and red-violet, avoiding the white highlight and leaving the top light and the reflected light, at lower right, untouched. Then I dampen the rear onion again, and float the graded washes (red-violet with a bit of orange) with a mixture of red-violet and brown light. Be sure to tilt the board to whatever angle is necessary to control the flow of the wash and to create the required shapes. Next, with clear water on the brush, I brush back and forth across the lines on the core of the cut onion to blur the divisions while tinting the whites at the same time. I must mention that I have placed the onions right before me to check colors and values as I proceed. Then, with yellow and yellow-green very much diluted I tint the heart of the core. I move to the skins that have fallen off and begin defining them with red-violet and brown light. Not worrying about details yet, but carrying the big shapes forward at the same clip, I deepen the cast shadows with blue-violet and brown light.

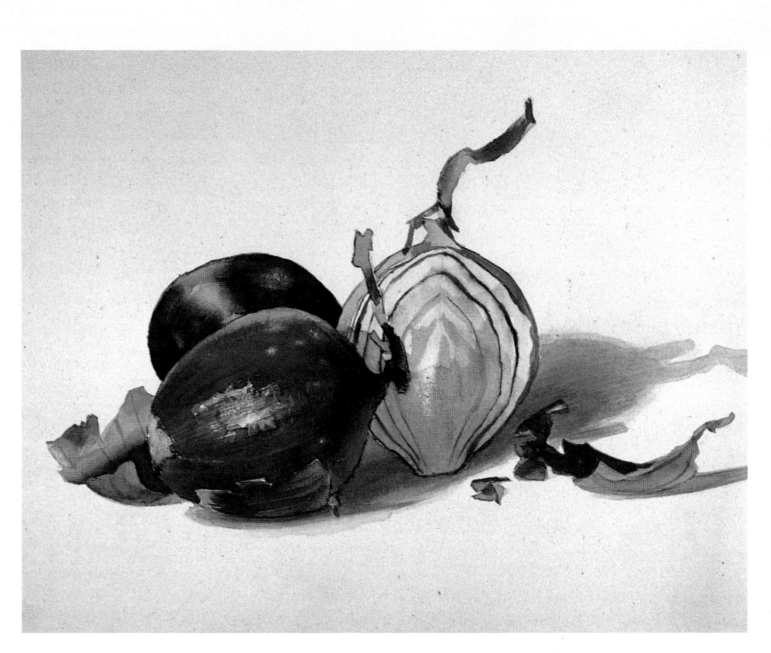

Step 4. I deepen the darks on the skins with red-violet, blue-violet, and brown light, and begin considering their detail. Before proceeding with the modeling of the front onion, I enlarge its highlight with the corner and the edge of the razor blade. Still working on the front onion, I dampen the area with the brush and while still damp I strengthen the form with deeper tones of red and red-violet. I render the light specks on the front onion using a brush charged with clear water, making sure that the board is level so the beads of water won't run. Then I pick up the dissolved pigment with the brush dry, and press a piece of paper towel to each spot before proceeding to the next one, to avoid leaving watermarks. Next, to paint the cast shadow on the core of the cut onion, I mix red-violet, blue-violet, and yellow-green. And last, I deepen the cast shadow areas under the onions by drybrushing a mixture of red-violet, blue-violet, and a touch of brown light.

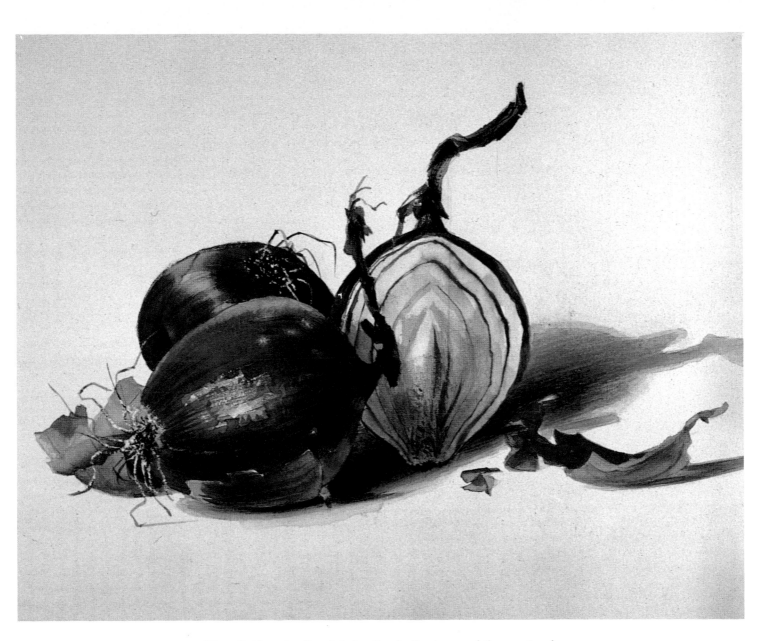

Step 5. Now for the details. To do the base of the roots of both the front and rear onions, I just dip into the dark puddles I used for the skins and shadows that are already on the tray. Then I give the base of the roots a few pecks with the corner of the blade to get their texture. Still using the corner of the blade, I scratch the roots and extend them over the light background and base with a tint of very diluted brown dark and yellow-green. With these same colors I move on to the stems and give them their final touches. As you see, there are no secrets in transparent watercolor; it's only a matter of following logical, consecutive stages—the first ones preparing the ground for those that follow. Once you've done this simple watercolor, or one of your own subject, employing these fundamentals, as your skill develops you'll be ready to tackle progressively more complex subjects. And I am sure you will, because that is my plan.

2
Buoys

Subject. My love for things old and battered drew me to these buoys, scarred by rough usage and long labor—the chipped paint, the assemblage of wood, cord, and twine, and the simple shapes in which "form follows function." Furthermore, while being a feast for the eye, they also stir the imagination with vistas of quiet coves, restless bays, and men who set out to harvest the sea. I paint them outdoors because that is the subject's natural habitat; to set them up in the studio would reduce them to mere decoration. Please forgive the twaddle, but I must tell you how I respond to the visual world, because without feeling there can be no painting.

Brushes. I used a No. 7 bright bristle brush for the first indication of the shingled wall; the rather stiff, short stock is well suited to get the texture I want here. Then I used a No. 20 flat sable, because when fully charged it can cover large areas, and the sable is soft enough not to disturb the underpainting. Next I chose a No. 6 Simmons White Sable, because its fine point lets me do lines as thin as I want. And finally, I used a No. 7 pointed watercolor brush for underlying washes and a No. 2 pointed watercolor brush for small details.

Other Tools. The Grumbacher Liquid Mask, a rubber cement tinted gray so you can see it when applying it, was especially useful in protecting the cords and the edges of the buoys while rendering the shingled background. And the razor blade was again indispensable for scratching out the fibers of the twine, correcting a white edge, and scraping light spots.

Palette. I think of my palette simply as red, yellow, and blue. The reds can range from a sober sepia or sienna, to a joyous scarlet or crimson, the yellows from an earthy ochre to a sparkling brilliant, and the blues from a soft cerulean to a somber ultramarine—all depending on the subject, of course. When sketching I'm not concerned with the quality of the color, but when working on a serious painting I switch to reliable and reputable trade names; Winsor & Newton is one of them. For this watercolor I've used their sepia, raw sienna, alizarin crimson, cadmium scarlet, New gamboge, ultramarine blue, and Davy's gray.

Painting Surface. The paper is 140-pound d'Arches rough which has the ideal surface to complement the subject, especially the shingled background. But rough as it is, it still lends itself marvelously to small details, and is strong enough to face a razor blade without flinching.

Medium. Here, as in the preceding demonstration, the medium is transparent watercolor. This time, however, I've used the pigment in tubes instead of the boxed cakes of color in the Grumbacher Symphonic set. Some artists add thickening or wetting agents to their color, or separate one layer of paint from another with sprays of fixative. There's nothing wrong with that, but the only agent I require is water, just plain tap water, to dilute the pigment.

Painting Tips. It's always a good idea to check the weather the night before the day you plan to paint outdoors. Don't encumber yourself with anything but the bare essentials. My sketching materials are in boxes labeled: transparent watercolor, opaque watercolor, acrylic, etc. This will avoid the frustration of leaving something behind, as long as you don't rob Peter to pay Paul. If there are no rags in one box, don't borrow from another, but put in new ones. I prefer to use a paper block because the sheets are secured on all four edges and will not flap in the wind. The Symphonic set is perfect for me when sketching in the field, and I try to save all the white areas I can, but if need be I don't hesitate to dip into white opaque for any effect I want. After all it's only a sketch and purist theories can go hang.

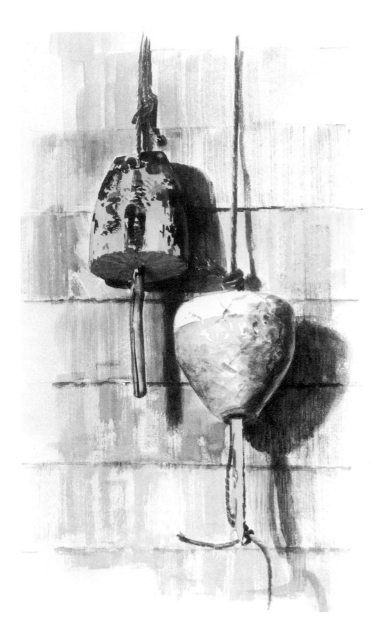

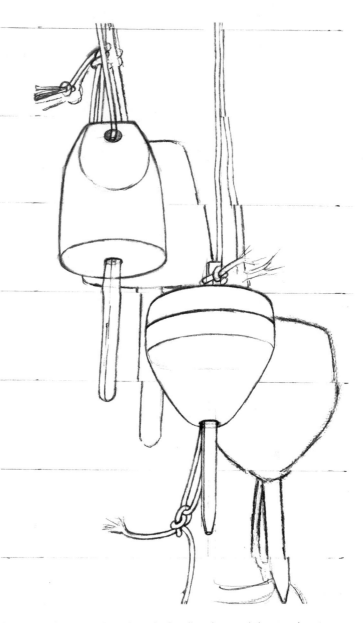

Sketch. There's hardly a time artists have more fun than when sketching. With utter abandon we dash things off unconcerned about explicitness or correctness, and the result is a vigorous and charming suggestion of the subject. It is this playful and broad indication of things that is so difficult to carry over to the final painting, especially for those of us in pursuit of precise realism. My purpose in sketching is to gather information, to acquaint myself with the subject, and to check the arrangement of a picture. The young artist should adopt this procedure, with the added incentive to train the hand and sharpen the eye. The painter learns partly by instruction but mostly by doing. Read and listen, but sketch, then draw and paint and sketch again. I did this sketch on a full sheet of a 12″ x 18″ (31 cm x 46 cm) Paper King pad, using the Grumbacher No. 30/17 Symphonic set, a No. 22 flat sable for the shingles, and Nos. 3 and 7 pointed watercolor brushes for the buoys.

Step 1. After I do the sketch, I refine it , and then using transfer paper I trace it on to the watercolor paper. Since buoys belong outside, I hung them on the south wall of the studio to get the information needed on modeling, cast shadows, and the character of the shingled wall. Then I took them into the studio and referred to them for minute details, but retained the lights and shadows caught in the outdoor sketch. Wanting more specific detail on the shingles, I went out and made a rubbing with a graphite stick and a piece of tracing paper.

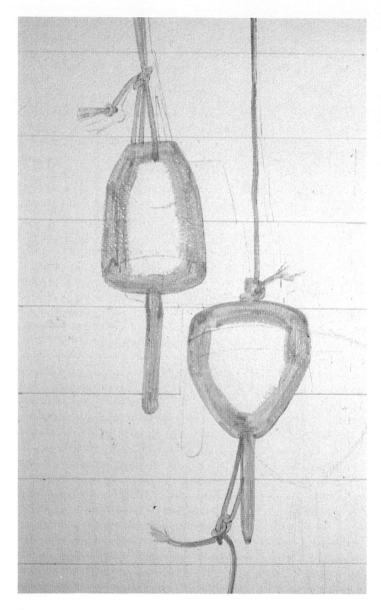

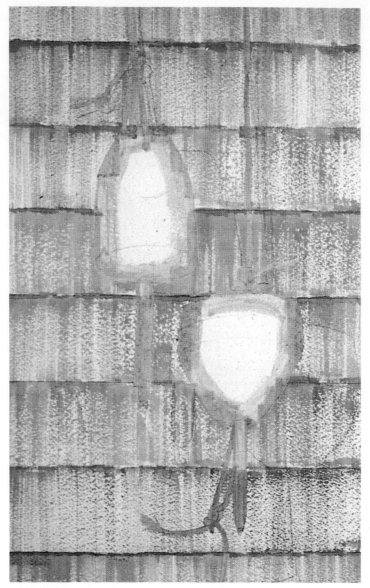

Step 2. I apply the Liquid Mask solidly on the cords and around the outline of the buoys. Perhaps I should mention just once more that I always transfer the working drawing to whatever support I have chosen. Many artists, as you know, do the drawing directly on the painting surface, but I prefer to paint with all the drawing problems behind me, especially when using transparent watercolor.

Step 3. After diluting Davy's gray in a nesting cup by dipping the No. 7 bright bristle brush into the water jar and with the edge of the brush, I tap the pigment until it thins evenly, and begin the shingled wall. From the top row I start, using quick, vertical strokes to get the texture, going over the cords and slightly into the protected outline of the buoys. Then with the tip of the same brush I tap the horizontal lines; actually the shadows cast by the bottom of the shingles are wider and sharper, but to do them as they are would conflict and detract from the buoys.

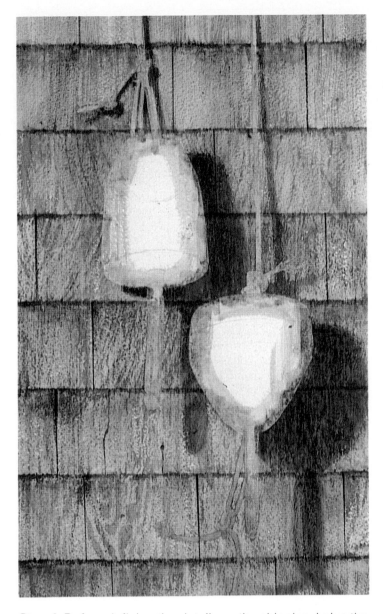 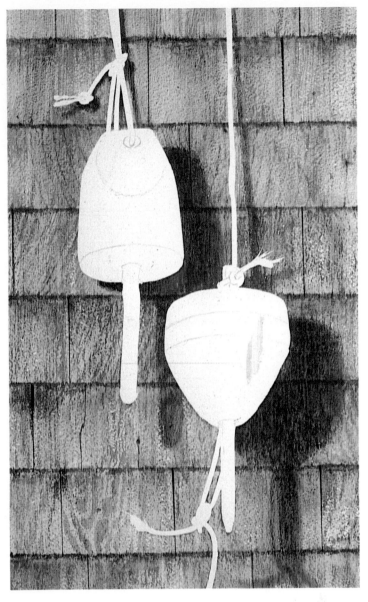

Step 4. Before defining the details on the shingles, I give the entire background a glaze of New gamboge and raw sienna, both to warm it up and to subdue the texture a bit. When it dries, I paint in the vertical divisions of the shingles with the tip of the No. 6 watercolor brush. Then with the tip and the side of the same brush, I render the grain of the wood and the shadows cast by the buoys, using sepia, ultramarine blue, and raw sienna.

Step 5. I've been eager to remove the rubber cement masking because I'm used to carrying the entire painting along from the very beginning. The bare white paper of the buoys makes it difficult for me to judge the correct color and value of the shingles. First, I tap and rub my fingertips on the film round the buoys, and as it comes off I keep the tiny ball of cement and continue to pick up the rest with it. Another method is to remove the cement with a pick-up, a latex square that lifts dried rubber cement.

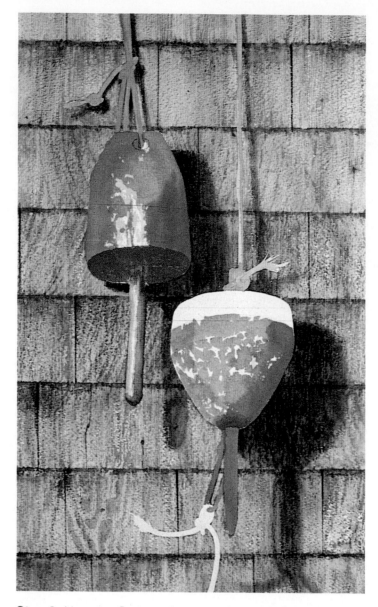 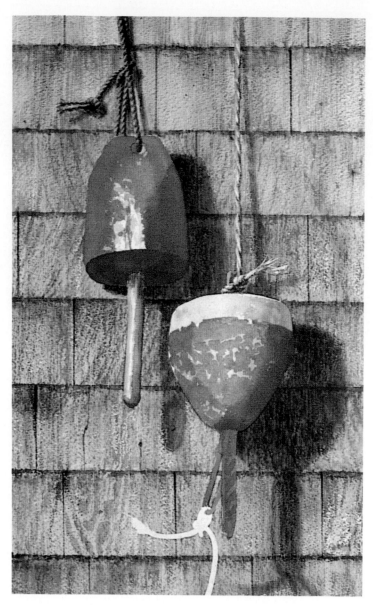

Step 6. Now, by George, I can begin to pull the picture together. I dilute a squeeze of New gamboge on the butcher's tray and paint the buoys with a No. 7 pointed watercolor brush, skipping the middle highlight of the upper buoy and saving the top and the light spots of the lower one. On the upper buoy, I also paint the handle and the loop of the cord behind it. Next, I put a speck of ultramarine blue and alizarin crimson on the tray, dip into them, and still with New gamboge on the brush I indicate the right-hand shadow on the upper buoy. Using the same colors, I switch then to the No. 6 White Sable to paint the cord, the twine, and the handle of the upper buoy. Rewetting the handle of the lower buoy to get a soft edge, I render the tiny shadow between the handle and the body.

Step 7. I begin the modeling of the buoys, after wetting them, with thin washes of ultramarine blue, alizarin crimson, New gamboge, and sepia—not preparing any mixture but mixing as I go along. Using this wash I then pick up a No. 2 pointed watercolor brush and begin defining the top cord; I push the twine a bit further to completion, and scrape it with the blade to bring out the strands. Notice that in pursuit of realism I leave nothing to chance, and develop form, color, and texture in carefully planned successive stages.

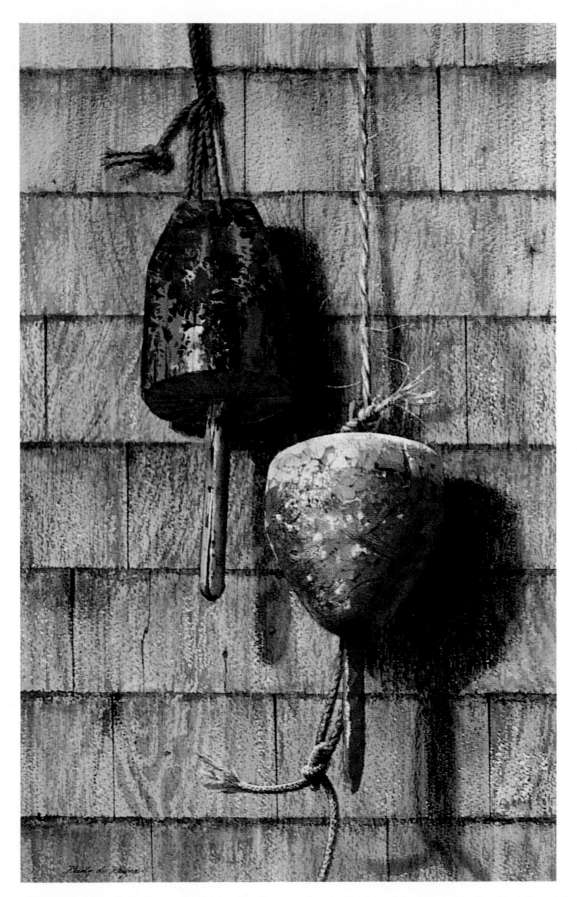

Step 8. I squeeze a speck of cadmium scarlet and using the No. 6 White Sable brush charged with full and medium strength (full strength is just enough water to make the pigment flow smoothly; medium strength uses more water to make a tint in the middle of the color intensity), I do the red spots on the upper buoy. Then with ivory black, full strength and diluted, I render the black streaks. With black still on the brush I dip into the cadmium scarlet and paint the red specks on the bottom of the buoy. I move to the handle and give it the last touches with the No. 2 pointed watercolor brush. Skipping down to the bottom of the picture, I paint the cord with the same brush. By this time I have enough puddles and paint on the tray to pick up any shade or tint I want. The pits, cuts, and cracks of the lower yellow buoy are done last with the No. 6 and the No. 2 brushes. If buoys are not available, then hang a pail or Indian corn on the wall—or do the wheelbarrow, the flower pots, the gardening tools, or whatever you enjoy painting.

3

Pink Balloon

Subject. There's no question that the whole gamut of emotions has been painted over and over since man's first paintings in the caves at Altamira. Ever since then, through the millennia there have been hunting, story-telling, romantic, and historical pictures, as well as propaganda, and I'm sure you don't want me to continue. The point is that all of us who are moved to paint will fall into one category or another, quite often unintentionally. It remains for the spectator or the critic to give us a label. And I suppose that's the way it should be, since a visual statement, like Gaul, would be incomplete in less than three parts: the painter, the painting, and the spectator. All this only to preface that I was drawn to this subject by the old weathered wall, the crumbling pavement, and the whole dismal scene brightened by the children and their pink balloon.

Brushes. Do you know that some artists prefer tired and worn-out brushes to anything new and unpredictable? I knew a chap who let it be known he would exchange brand new watercolor brushes for old ones, as long as there was a bounce or two left in them. Personally, I prefer new ones—at least not past middle age, or they wouldn't be able to respond properly to my demands. But I do give the less arduous tasks to my old friends—like stippling, stirring, rubber cementing, washing out, and things of that nature. Because brushes are an extension of yourself, you'll find that they're chosen by the promptings of the heart as well as the counsel of the head. I didn't realize until this painting was finished that I had used only pointed watercolor brushes, Nos. 1, 3, 5, 6, 7, 9, and 10.

Other Tools. Here again I've used the Luma "Liquid Mask," not much but enough to let me render dark elements behind light objects without worrying about encroaching on their contours—in this case the balloon and the flower pot. Also I used a synthetic sponge to wash and lighten a tone that came off too dark, some masking tape to contain the area that needed washing, a white Stabilo pencil for the mortar on the brick wall, and the razor blade to pick out small details.

Palette. One of the important procedures I'd like you to add to your technique is the glazing of a hue over its complementary: red over green, orange over blue, and yellow over violet. The result is far more interesting and lively than if the colors were to be mixed beforehand on the tray. Do practice on scraps of paper in whatever combinations you wish, and save the exercises for use in future work. In this demonstration I have glazed a red over a green, but it'll be better to mention the rest of the colors when we get to the painting.

Painting Surface. Following the precept that larger paintings are done better on double thick supports, I picked a Crescent watercolor board No. 112 rough, with Strathmore 100% rag surface paper. Delightful and inviting to work on, and like the d'Arches paper, rough enough to easily get whatever textures are required. And if a smooth spot is needed for tiny and intricate detail, it can be obtained by rubbing the area with a wad of fine steel wool. I must caution you again that this sort of thing cannot be done on cheap paper.

Medium. I've used the No. 30/17 Grumbacher Symphonic set of watercolors for this 21½″ x 17″ (55 cm x 43.2 cm) to dispel any notion I might have given you that it is adequate only for sketching or small paintings, like the onions in the first transparent watercolor demonstration. And after finishing this work, there's enough color left to do others of the same size. You see, working from the cakes themselves, not a speck of paint is wasted.

Painting Tips. When glazing one color over another, be sure that the surface is completely dry. Another precaution is to use a sable brush, pointed or square, so that the underlying layer of paint will not be disturbed. When using paper of lower quality than the ones I've mentioned, be sure to pat and mop without any brisk rubbing. A pencil sharpener is a bit too aggressive for the Stabilo pencil. Better to sharpen it with a blade, and to keep the point rather short so it won't break under the hard pressure required for the job at hand.

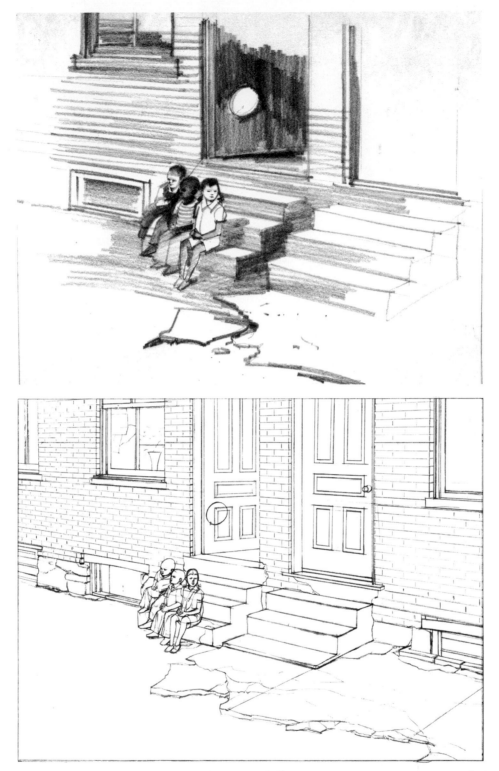

Sketch. (Top) This sketch is based on an excellent photograph lent to me by a friend. The tonal arrangement was beyond improvement and all I did was to delete some debris from the foreground so it wouldn't conflict with the center of interest—the children. My first impulse was to include a white, a black, and an Oriental child to convey the idea that children are unaware of these distinctions and always find understanding and companionship in each other—only to be blighted later by prejudice and bigotry. But I changed the children to black because I felt that the moral and social issues I was touching on belonged more to literature than to painting. I did this rough on tracing paper with a No. 2 office pencil; I'll use the tonal scheme in the black-and-white photo, but I plan to enlarge the setting because at their age I remember living in a world of gigantic and wondrous proportions.

Step 1. (Above) I place a piece of clear acetate over the photograph, divide the 8″ x 10″ (20.3 cm x 25.4 cm) area into quarters both vertically and horizontally, which gives me four 2″ (5.1 cm) divisions up and four 2½″ (6.4 cm) divisions across. Then resting a white Stabilo pencil against a ruler's edge I run the lines across to form a grid. I place the photo with its grid at lower left under a 19″ x 24″ (48.3 cm x 61 cm) piece of tracing paper, run the left boundary up to 17″ (43.2 cm) with an office pencil and a straightedge, throw a diagonal from lower left corner through upper right of the photo, and where the horizontal at 17″ (43.2 cm) and the diagonal meet, will mark the vertical boundary of the enlarged area, which turns out to be 21½″ (55 cm). I divide the 21½″ x 17″ (55 cm x 43.2 cm) area into quarters to get the enlarged grid in proportion to that of the photo and I'm ready to begin enlarging by checking the respective squares in the grids, and the elements they contain.

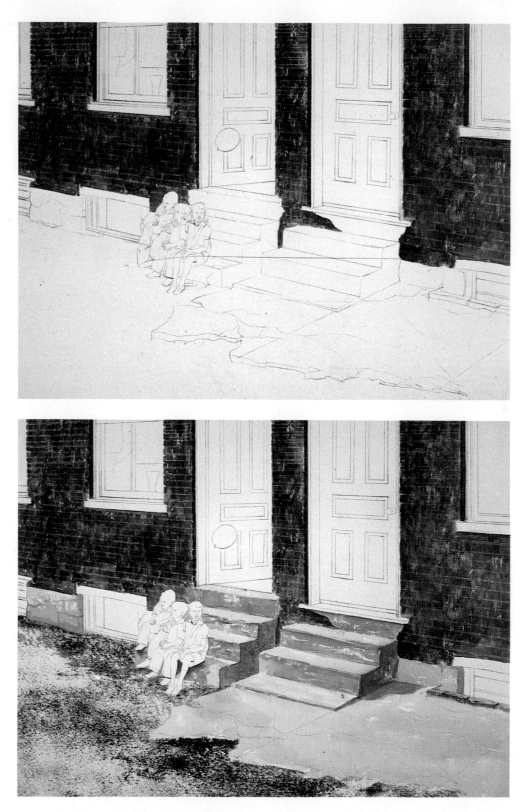

Step 2. (Top) Guided by the converging lines in the drawing I find the left vanishing point (outside the picture area) and stick a pushpin in it. Placing the straightedge (actually a T-square blade unscrewed from its head) against it I begin at the top and work my way down running the white Stabilo pencil along the edge in short back-and-forth strokes. It's hard to see the white lines between the bricks on the white paper, but I've marked with an office pencil the right number of brick rows on the left picture border and I know they're at the right distance from each other. Then with green and a touch of brown light I give the wall its initial wash with the No. 10 watercolor brush. By loading the brush fully and by turning it, I've given the wall a blotchy and uneven tone.

Step 3. (Above) I tackle the other large area in the picture while the green on the wall dries completely. With the No. 10 brush I form three puddles on the tray: brown dark, yellow ochre, and red orange, rinsing the brush of one color before picking up the next one. Now with four puddles, including the green, I pat a piece of synthetic sponge into all of them, test the resulting gray on the margin of the paper and then tap it on the bare ground both for color and texture. I switch to a No. 5 brush and, adding red and red-violet to the ground mixture, I begin to render the steps and the stone foundation of the building. I'm using the side of the brush for texture, while skipping some whites. Next, with the No. 10 brush and in the same manner and for the same purpose I apply the first wash on the pavement.

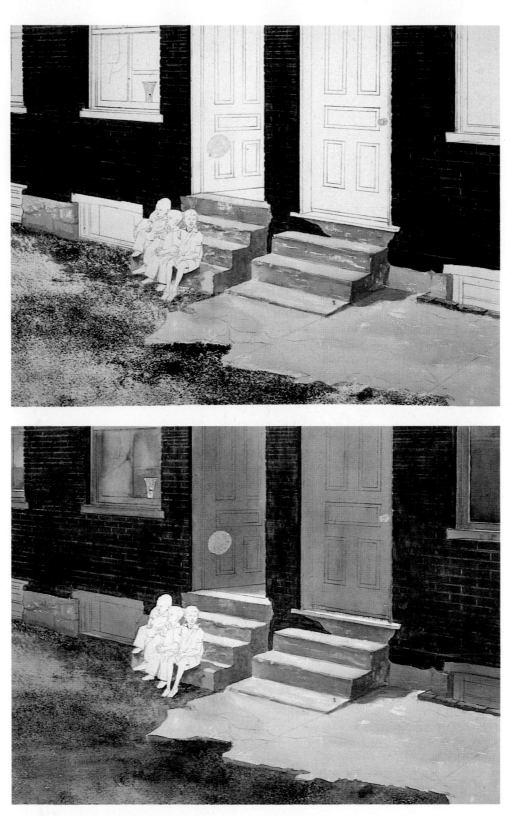

Step 4. (Top) With the No. 7 brush I gently float a wash of red and red-orange over the green wall. It looks darker than it actually is because of the glaring whites against it, but I'm quite sure it's the value I need. And if it isn't, I can always wash it to a lighter tone. I use the point for the edges against windows and doors, and the side for the areas between them. I'm still applying uneven washes to get the blotchy and weathered effect I want. Then, with an old No. 3 brush I mask the vase in the window, the balloon, and the door-knob.

Step 5. (Above) After mixing red, brown dark, and blue in a dish, I float the color on the doors and windows; it's just a lay-in to cover the whites as quickly as possible. Since I have battalions of old brushes, I use one for each color when I mix from watercolor-set cakes to keep each color pure and unsullied. In another dish I mix a quiet green with yellow ochre and blue, and, with occasional dips into the color for the doors, I float a wash over the bare ground with the No. 10 brush.

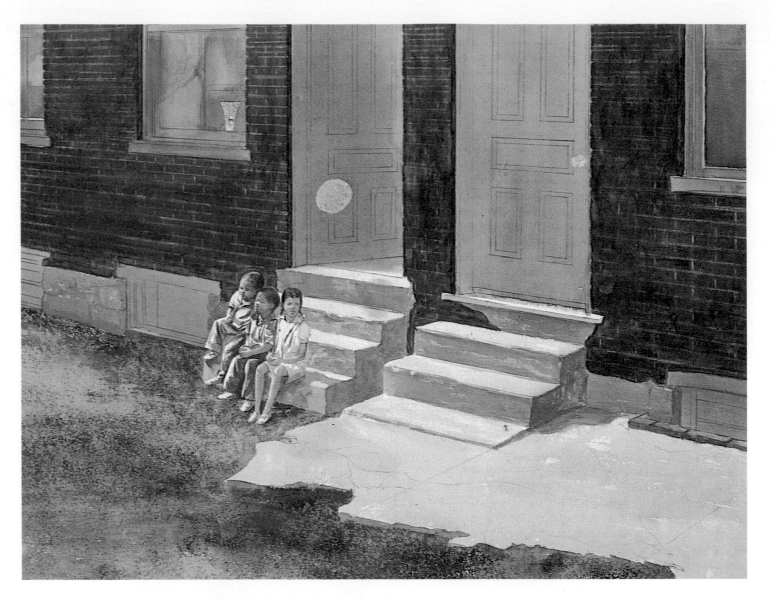

Step 6. The light top planes of the stairs and the light value of the pavement do not disturb me at all because they are to function in this high key as part of the overall tonal scheme of the picture. I must begin rendering the children now. After transferring dabs of brown dark, red, red-violet, yellow ochre, and blue to the butcher's tray I begin the underpainting of the flesh. I mix the tones as I paint, aware of the modeling of the head and the character of the folds on the clothing. I'm using the No. 1 brush for hands and faces, and the No. 3 for the rest.

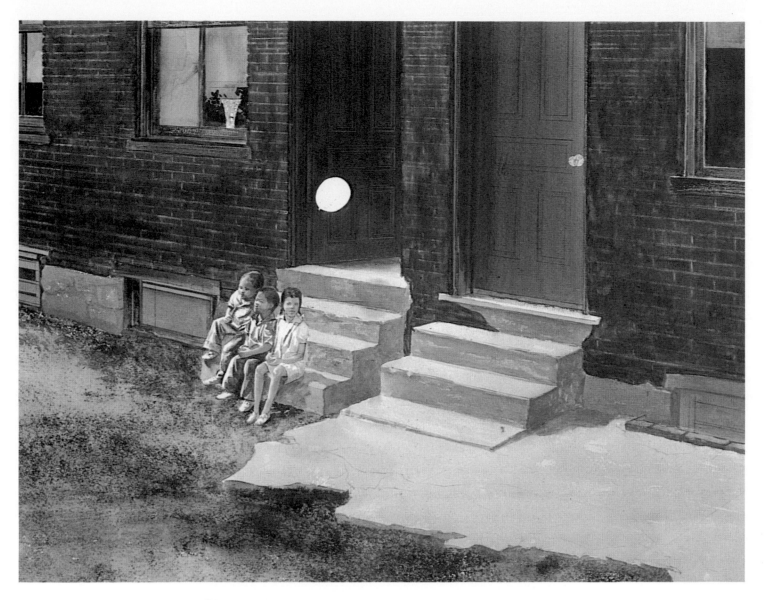

Step 7. First I finish the door behind the balloon because I can't remove the masking until every detail behind it is done. I use the ruling method for the panels in quick strokes to get the weathered texture, being careful to leave the original lighter wash for the lights on the molding. This I do with mixtures of brown dark and yellow green, using Nos. 3 and 6 brushes. Moving over to the door on the right, I repeat the procedure. With the No. 3 brush I do the windows by adding a whisper of red to the mixtures applied to the doors. Now the steps and the pavement are too cool in relation to the rest of the picture, so I give them a glaze of very diluted yellow ochre with the No. 9 brush. The window in the right corner came off too dark; I must wash and wipe to lighten it. As you see, I've removed the masking from the balloon.

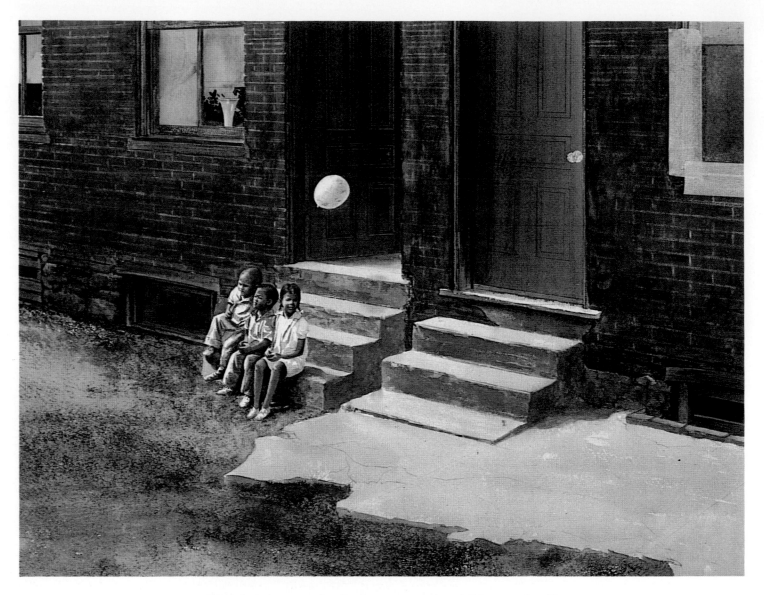

Step 8. I dampen the flesh areas on the children and, still using the Nos. 1 and 3 brushes, I strengthen the modeling with deeper tones of the colors used in Step 6. They're predominantly cool so I can get the right color when the warm glazes in Step 8 are applied. Then, working from green and red dabs on the tray I deepen the shadow planes on the steps with Nos. 3 and 7 brushes. Then, with a No. 5 brush I add a dab of brown dark to join the red and green for the basement windows. Notice I've stuck pieces of masking tape around the right-hand window to be washed. Using a No. 3 brush I wet the balloon and give it form with its underlying green color. Next, I remove the cement from the vase and give it a tint of violet.

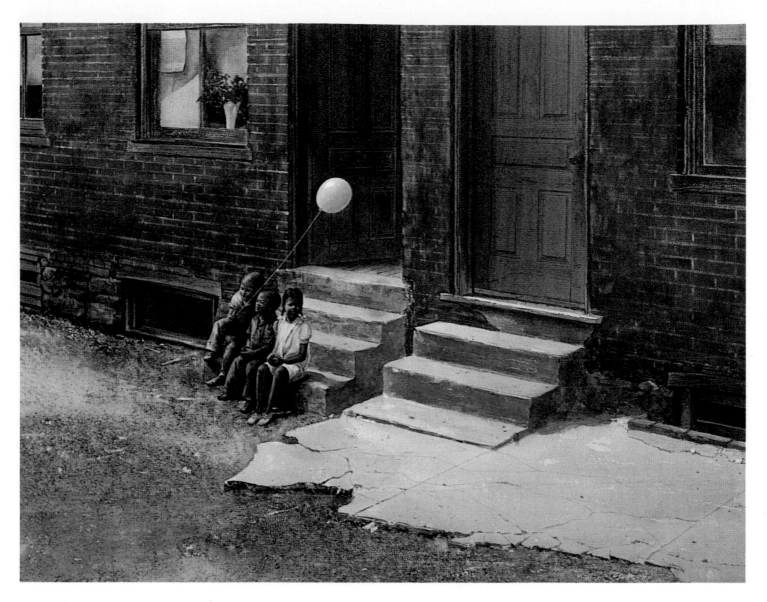

Step 9. Now the last touches—for the perfection we all pursue and hardly ever attain. First, I rewet the balloon and, with a tint of red I go over the green, still saving the bare paper on the upper left-hand side for the highlight. With pink still on the brush I dip into yellow ochre and give the girl's dress another glaze. I continue with the flesh on all three children, warming it up and deepening the shadows with brown light, red, and yellow-green. I move from the heads to the clothing and back again, as I define the boys' attire with blue, blue-violet, red-violet, green, and brown light. Next, with blue-violet and brown light, I darken the window on the right and the shade in the left corner, and define the one above the children. I add the leaves and give the vase a tint of green, and then after scraping their position, I do the pink blossoms. I darken the edge of the pavement and define its cracks, render the doorknob, scrape the light litter on the ground, and finally—after cutting a thick piece of acetate in exactly the curve I want, I rest the corner of the razor blade against it and in one quick sweep I scratch the string for the balloon.

4

Low Tide

Subject. There's something so appealing about an old wharf that I shall paint them until I die—or as long as they remain, whichever comes first. They are an endangered species, you know; I refer to the old rickety, weather-beaten skeletons still tottering along the coasts of Maine and Nova Scotia. Even when in search of another subject, it's not easy to ignore the lichen-covered stanchions, the muted color, the marvelous textures. Add to this the disposition of planes and lines that so easily fall into an exciting abstract design where the realistic aspects of water, wood, and weather can be hung, and I know I can't resist.

Brushes. As there are paintings that can be done with a single brush, there are those that require not only a whole detachment of them but also units from Special Services (if I may place liquid masking and the razor blade in the ranks of the latter). Here, for instance, I began with a No. 22 flat sable for the largest areas of sky and water, and finished with a double zero (00) for the tiniest details. Also put into service were pointed watercolor brushes Nos. 3, 8, and 10; bristle brights Nos. 4 and 6; and a No. 6 Simmons pointed White Sable. I shall describe their individual accomplishments when we get to the painting.

Other Tools. Imagine how difficult and awkward the rendering of the sky and the water would be here if I hadn't used the Luma liquid masking. Instead of working freely into the edges of the buildings and swiftly across the stanchions, I would have had to stop at the edges, thereby destroying the rhythm and continuity of the two elements behind the wharves. If I knew who first used a knife to scratch out lights I would crown the person with the highest honors. Without the razor blade, I could not have done the slats on the roof and on the walls of the shack as well as countless other light details. A 24″ (61 cm) ruler was used as a mahlstick and to render the straight lines on the buildings, and I used a few paper towels to mop up the dry lift-offs.

Palette. Something that few of us ever think about is that artists of old had to prepare their own colors. I must admit it takes the curl out of my mustache just to imagine having to grind the blasted pigments, boil the binding glues, and worry about the purity and permanence of the other things involved. So I never fail to bless the color chemists who took it upon themselves to prepare our pigments so that all we have to do is squeeze a tube or dip into a jar. I've chosen Winsor & Newton cadmium scarlet, alizarin crimson, burnt sienna, burnt umber, sepia, New gamboge, Hooker's green deep, cobalt blue, Payne's gray, and Davy's gray.

Painting Surface. It was no idle whim that first led papermakers to make a variety of surfaces, from smooth to rough, for the artist to do his work on. As particular brushes are chosen to render a given job, so a special surface must be selected on which to paint. Aside from the textural quality, in this case, rough, one should always anticipate the possible punishment that a subject may inflict on the paper. After studying the sketch, I knew I would have to scrape and scratch mercilessly, to wet and rewet and rub with bristle brush and mop with paper towel. So I picked up the d'Arches 140 pound rough—the ideal surface the subject calls for, and a sturdy enough paper to face any tool.

Medium. Since this will be the last transparent watercolor painting, I'd like to remind you that I've adhered to the purist way of handling it only to show you the possibilities of the medium alone without the aid of any supplement. It doesn't mean that you should be as stern a disciplinarian. Some of the medium's inherent playfulness and exuberance can be released without sacrificing realism; it's really up to you, your feeling, and your vision.

Painting Tips. There are times when only a portion of the drawing should be transferred to its support. It would have been pointless to have traced more than the contour of the elements here because when I picked up the liquid masking I would have also removed the drawing under it.

There's nothing more distressing to behold than a No. 2 brush laboring to do the work of a No. 7. So, remember to switch to a smaller brush when the larger one becomes unwieldy. Besides the conventional watercolor brushes, it's good to have a few bristle brights; they're better for picking up lights or raising a tone.

Even the young artist knows that a watercolor should not be exposed to direct sunlight. But it should also be realized that indirect or artificial lighting can discolor the better papers and fade the "permanent" pigments. Ideally, watercolors should be kept in portfolios or facing the wall until ready to show. Just one more tip: after you have mastered the medium in the purist manner, then you can call in reinforcements—not to cover up flaws, but to make your statement more expressive, both visually and emotionally.

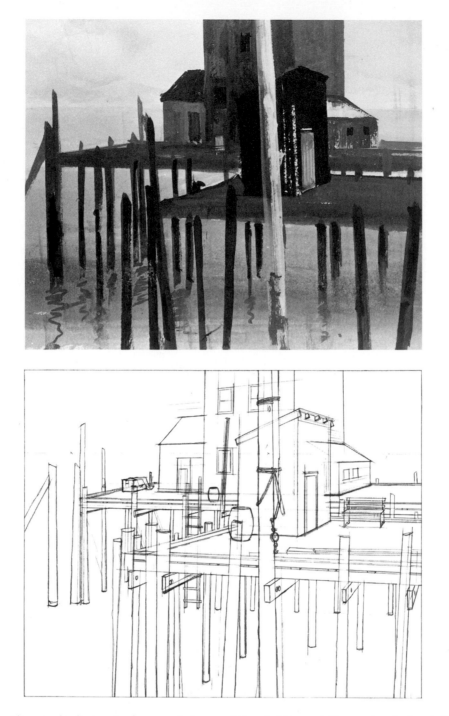

Sketch. (Top) Even though we pinch most of our painting subjects from nature, there are times when a painting is influenced by another painting we have seen—just as some musical ideas are conceived after hearing another person's music. There was an abstract painting I saw at an exhibition and its undeniable echoes of Mondrian haunted me long afterward. I had no choice but to put the pesty thing to work in one of my pictures and be rid of it. That's how I came to do this sketch. The place exists nowhere; it was done from memory and imagination, reaching only for composition and color. It measures 4¾″ x 6″ (12.1 cm x 15.2 cm) and I used the Pelikan color box and Nos. 3 and 6 brushes on a Paper King pad. I must point out that although this work is purely imaginative, I based it on the countless wharves I've seen and studied.

Step 1. (Above) One school of painting advises the student not to draw, but to begin by painting the tonal shapes in a given composition. Working in this manner, the linear drawing becomes unnecessary. This is all very good, of course, for the chap who has already trained his eye for correct proportions and relationships. But what about the young artist who is still in the process of learning how to draw? So, sound as the procedure is for the seasoned painter, I cannot advocate it, for the simple reason that it's much easier to change a pencil line than to alter the shape of a tone—no matter what the medium. This is especially true when working in transparent watercolor, because any change would mar the picture. Therefore, throughout the book you'll see the linear structure of the elements ready to be traced to the support. All the alterations and refinements have been done; the drawing is out of the way and the remaining problems belong to painting alone. Divide and conquer is a good motto, and I didn't ignore it when I was a student.

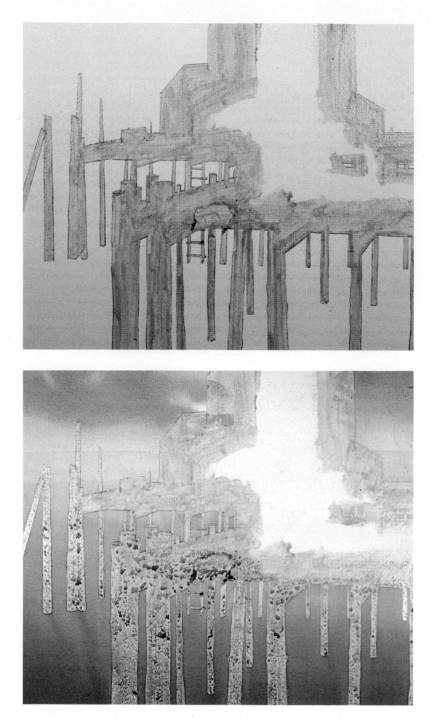

Step 2. (Top) With a 5H pencil I trace only the contours of the elements onto the d'Arches 140-pound rough watercolor block. Then, I apply the Luma liquid mask with an old No. 5 watercolor brush. I work the masking well into the contours and solidly cover the thin and narrow shapes so that when the background is done I won't have to worry about slipping over into the main subject. I work as quickly as possible but even so the masking begins to accumulate round the ferrule of the brush. So after rinsing the brush vigorously in the water jar, I pull off the stuff with my fingers before continuing. Remember to use old brushes because any brand of masking has a tendency to split them; that is, the hairs separate into two or three groups.

Step 3. (Above) Resting the top of the block of paper on the drawing table (at an angle of about 45 degrees), and holding the bottom of the paper in my left hand so that it lies almost flat, I begin wetting the sky area with a No. 10 pointed watercolor brush. The picture measures 13⅜" x 16⅝" (34 cm x 43 cm). Then, on the wet surface and using the same brush, I float the clouds with a mixture of burnt sienna, Davy's gray, and Payne's gray, letting the warm Davy's gray dominate. I tilt the block of paper to control the shapes of the clouds, and if a light shape begins to close up I immediately widen it with a damp No. 8 brush. After the sky has dried, I wet the water area. While still damp I take a No. 22 flat sable and apply a graded wash, lighter at the top, using the same sky mixture, but this time I let the cool Payne's gray dominate the other two.

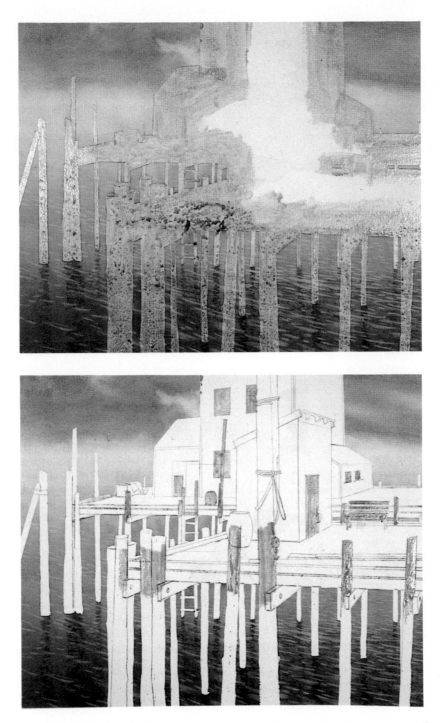

Step 4. (Top) When the graded wash dries I dip a No. 4 bristle bright in clear water and rub the shapes of the ripples to dissolve the pigment; I wait a few moments and then mop them up with a crumpled paper towel. This is done shape by shape because the lift-offs should be mopped while the water still glistens or there's a chance of leaving a watermark around the edge. As I define the ripples, I refer to an Instamatic snapshot I have of water just like this. I remember taking it somewhere on Cape Cod, not expressly for this picture but because I knew that some day I'd need such information. Whenever you come upon something that might be useful, don't hesitate to photograph it and keep it for future reference. One word of caution: Do not attempt scrubbing off any lights except on first-rate paper like this one or similar reputable brands.

When I finish the ripples I wet and rub the horizon—above and below, with a No. 6 bristle bright and mop it with a paper towel to lighten it still more. I want the horizon to get lost between the sky and the water. Then I paint the stanchions' reflections on the water using deeper shades of burnt sienna, Davy's gray, and Payne's gray. Then I step back and study what I have done; I don't want to touch the background after the cement is removed. Next, using the No. 22 flat sable in horizontal strokes from top to bottom, I warm up the whole thing with a very light glaze of New gamboge. I rewet the horizon and mop it dry with a paper towel.

Step 5. (Above) After removing the masking with a rubber cement pickup, I rub the lights on the clouds with a kneaded eraser to make them still lighter. Then, I replace the drawing from Step 1 and tape it in position to trace the detail within the contours. Next, I mask the various things that I intend to keep light or brilliant in color as well as the vertical elements over a horizontal plane, like the stanchions against the docks. Note the left edge of the tall building where the paint crept under the masking. Not to worry; I deliberately left it to show you how easily it can be scraped off. There are many other light details against dark areas, but they need no masking because they're small enough to be scratched out with the razor blade after applying the tones.

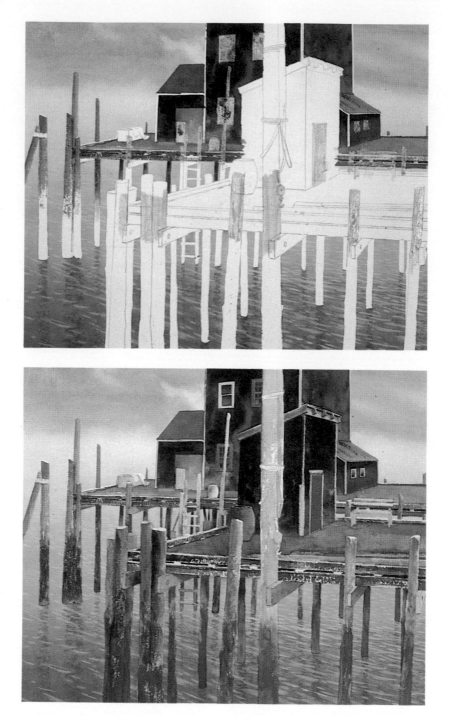

Step 6. (Top) Now I squeeze dabs of sepia, burnt umber, Hooker's green dark, and cobalt blue in the nesting dishes. Using pointed watercolor brushes, No. 8 for the big shapes, No. 6 for the roofs and the door, and No. 3 for the stanchions, I begin painting from the background to foreground and float the dark tones that are mixed on the butcher's tray. When I notice an area turns out too cool, I drop a little sepia or umber into the wash to warm it up. By the same token, if too warm, I drop blue into the wash. The block of paper lies almost flat when doing this so the color won't run down. The purpose is to liven up the tones with variegations of cool and warm color separately introduced, instead of a pre-mixture that would be flat and dead. I'm using the ruling method for all the straight edges on the building. I dip into the puddles on the tray and dilute the color a bit with a No. 8 brush, then I apply it in quick strokes to the side of the wharf to begin the textural effect I want. After recharging the brush I float the same tone on the deck.

Step 7. (Above) With a razor blade I clean up the left and right edges of the building, and then continue with the big shapes after removing all the masking. I'm still not thinking of any details yet, just trying to pull the picture together with the right tones and color values. With the No. 8 pointed brush I add more burnt umber, cobalt blue, and Hooker's green dark to the puddle on the tray, and apply the almost black tone to the front shack. Then with a No. 6 brush, I dilute the color to do its top and the corner slats. Moving down to the foreground, I paint the top of the stanchions and the understructure of the wharf; the top and the side were done before I picked up the masking. With the same color, I go on to the barrels, the ladder, and the gear box in the distance, changing brushes from a No. 8 to a No. 6 and a No. 3 to a No. 2—depending on the size of the elements. Next I give the posts their first green underpainting of lichen with the No. 6 brush, by squeezing a dab of New gamboge and mixing it with Hooker's green dark as I go along. With the same brush I apply the brilliant notes of cadmium scarlet to the door and two of the windows. They're much too strident but I plan to subdue them later.

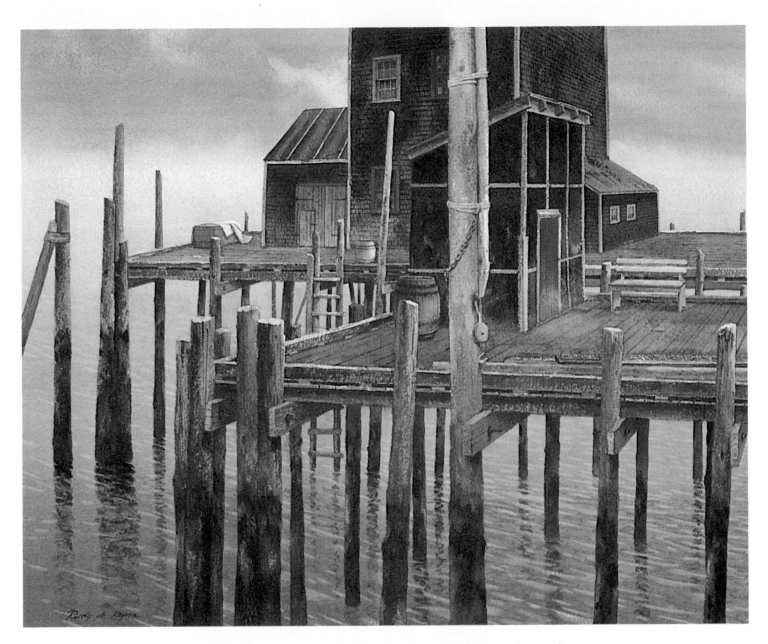

Step 8. I begin details by scratching the slats on the roof with the corner of the blade, and then I rub and lighten the middle section of the roofing paper with an office pencil eraser. Next, using the No. 6 brush, I lower the intensity of the red door and the two windows with several glazes of Hooker's green dark. In transparent watercolor it's easy to subdue a brilliant passage but very difficult to regain it. After wetting the lower part of the door I mop the color off with a paper towel. For the lichen on the posts, I use the No. 6 with a mixture of Hooker's green dark and sepia, adding raw umber to render the dark blotches. Then I subdue the textures on the side of the wharves with thin washes of the original colors, and I scratch out the slats on the shack. I go back to the building and paint in the shingles with a No. 2 brush, rubbing a No. 3 flat sable across them if they get too distinct. With a small brush, I put in the hinges and other details on the left-hand large doors; then I do the bolts on the stanchions, the hoops on the barrels, the gear box in the distance, and the lumber on the deck in the foreground. Next, I touch up the white bench, add a touch of green and sepia to the slats on the shack, refine the little windows in the back—and there you are. All this without adding any new color; there are enough puddles on the tray to get any shade or tint I want.

5
Three Oranges

Subject. In this painting I was in a quandary about whether to use the basket or a wooden bowl. A wooden bowl would have worked just as well without the chore of rendering the intricate weaving. My vacillation ended when I decided that the basket would be a challenge and good training for the student and no problem at all for the accomplished artist. Besides I needed the "pattern" of the basket to complement the smoother textures of the fruit, the table, and the background. Why oranges and a grapefruit? Simply because I deliberately choose bright-colored things to liven up the muted palette that my favorite ramshackle subjects demand.

Brushes. One notion I'd like to dispel is that watercolors are to be executed only with watercolor brushes. Certain passages and effects are much more easily achieved with a bristle flat or bright. After wetting, the short bristle of a bright brush is ideal for wiping out lights on a dry surface, to mention just one example. The rest of the brushes put to work here were Winsor & Newton watercolor brushes Nos. 1, 3, 5, and 7.

Other Tools. Since no unorthodox tools were used here, I'll take the space to urge you to investigate the "office pencil." It comes in four grades—from No. 1 extra soft, to No. 4 extra hard. My favorite is made by Dixon, and the trademark is Ticonderoga. As you may have noticed I use the No. 2—soft enough for deep darks, but not so soft that it must be sharpened constantly.

Palette. When I first came upon the Pelikan color box I remember giving it a disdainful glance and nothing more. Then a friend suggested I try it—I did, and I've used it constantly ever since for sketching outdoors and for small works in the studio. Since the palette is the box itself, I'll mention the colors used when we begin painting.

Painting Surface. The Crescent watercolor board No. 112 with the 100% rag surface paper is so delightful to work on that I use it for opaque watercolor almost exclusively. Its surface meets the requirements for any subject. In this case, the paper's roughness easily gave me the texture of the oranges by simply rubbing the side of the brush on it. And yet it allowed me to render the meticulous detail on the basket with no trouble at all.

Medium. On the chance that this vitally important point may pass unnoticed, I shall stress it now in capital letters: OPAQUE WATERCOLOR MUST BE GENEROUSLY DILUTED. Most artists unacquainted with opaque use it in such a thick consistency that it balks at the faithful detail demanded by realism. The reason I'm using the Pelikan box for this first opaques demonstration is that brushing the color off the cakes will give you a better chance to dilute it correctly. Adding water to pigment squeezed out of a tube would run the risk of leaving it too thick and unmanageable.

Painting Tips. When rendering a complicated object like the basket, I find it expedient to secure the drawing with India ink—using either a Gillott pen or a brush. I use the Gillott pen under rather thick paint, and the brush under thin washes. Moisten only the cakes required to do your painting but not every color in the box. The more wettings they get, the more their binding vehicle is diluted, causing subsequent work to disturb and "pick up" the underpainting.

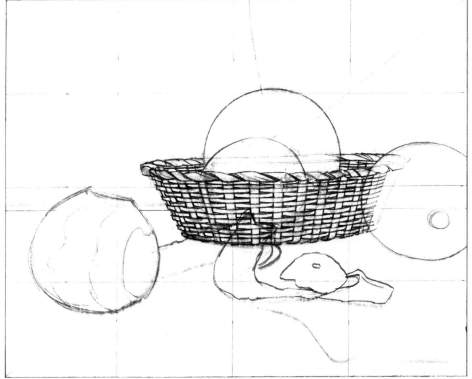

Sketch. (Top) In case I've given you the impression so far that the best painting method is to begin with a sketch, let me set things straight right away. Though it is the procedure I follow, it certainly doesn't mean that you should be burdened with it if you find it a tedious bore. I think any approach to painting should be bent to suit the individual artist. If some of us cannot proceed without careful preparation, there are those who must directly attack canvas or paper in a transport of excitement; to dally with sketches and drawings would only dissipate the white heat of inspiration. Always follow your own promptings and inclinations. The creative processes are too complex to fit into any rigid method or plan. This 6″ x 8″ (15.2 cm x 20.3 cm) sketch was done on the Paper King pad, using the Pelikan color box and brushes Nos. 3, 5, and 7.

Step 1. (Above) When arranging a still life I usually strive for a pleasing combination of straight and curved lines, but there are times when I purposely let the curved shapes dominate the picture. Because line is such an esthetically ambiguous term, I refer in this instance to contours delineating the objects. I'm sure it has not escaped you that we tackled the same problem—of arranging spherical elements—in the very first demonstration.

I used a No. 2 office pencil on a tracing paper pad. If any line went "out of drawing" I erased it with a kneaded eraser before correcting it. Notice there's no detail except on the basket because I plan to render the rest from the fruit itself.

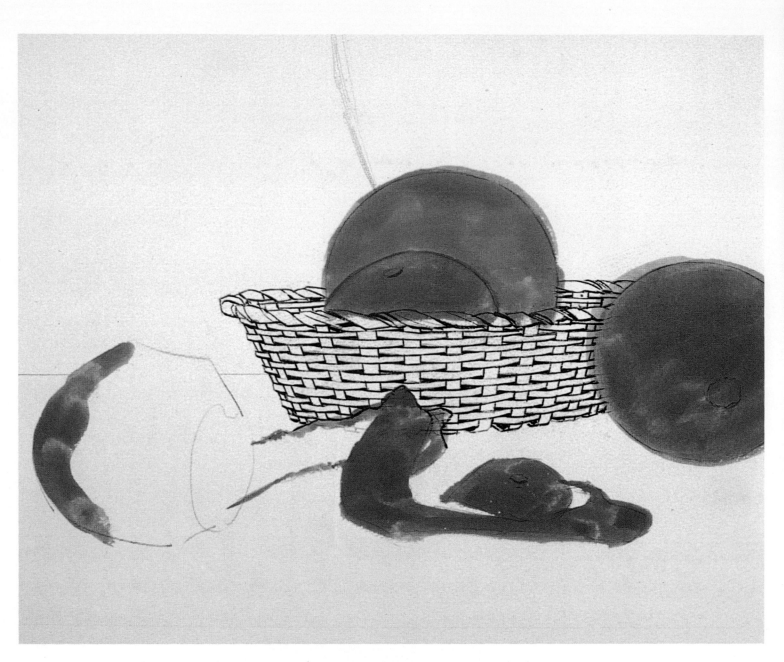

Step 2. With a No. 1 watercolor brush and Winsor & Newton India ink, I reinforce the traced lines on the basket. I do this so I won't lose the drawing when I begin applying the opaque watercolor, even in the thin consistency I'm going to use. Next, using lemon from the Pelikan box with a No. 6 bristle bright, I paint the flat middle value of the grapefruit. Then I dip into the orange pan to render the oranges and the peel. I'm painting slightly past the contours of the fruit because it's better to trim back later with the contiguous color than to leave white paper lines between one object and another—as I've seen so many students do.

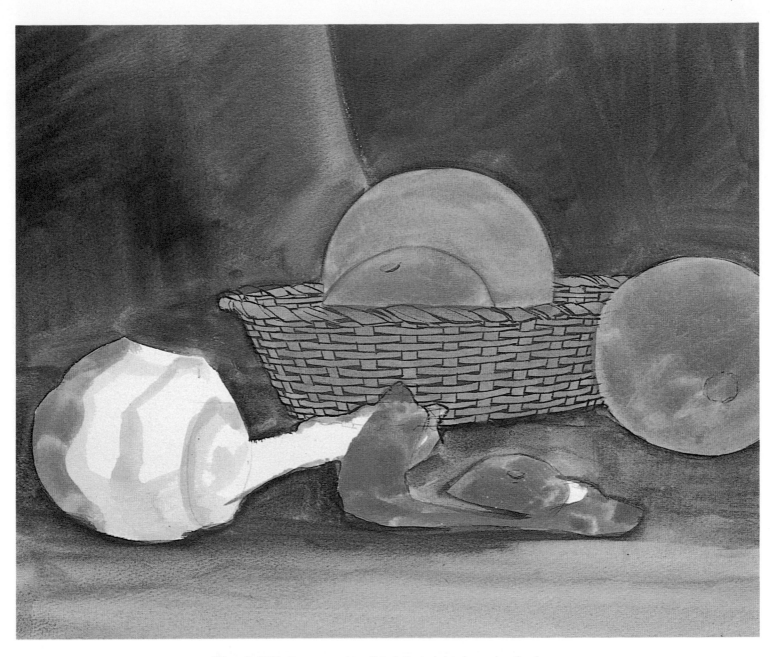

Step 3. With the same No. 6 bristle bright, I render the basket by dipping into yellow ochre, with touches of burnt sienna and raw umber for the thin layer of paint I apply. Note the paint is so thin that the underdrawing in ink is clearly visible. Then I move to the background with the same brush but using black, ultramarine blue, and violet, plus a touch of raw umber, stirring the mixtures on the butcher's tray. For the soft transition to the table, I add orange and burnt umber to these tones. The only hint of tone gradation so far is in the background and on the table. The rest of the elements are painted in flat middle tones of their local color.

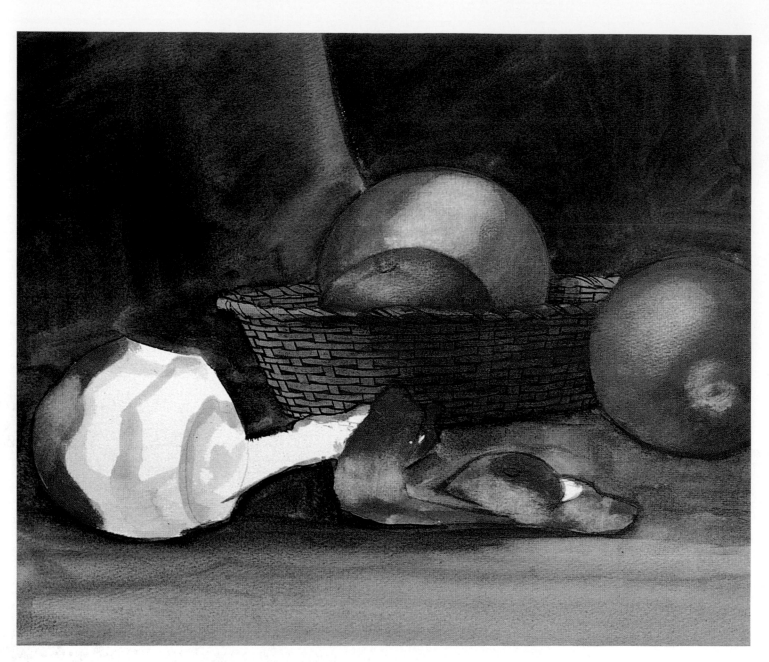

Step 4. With a No. 5 watercolor brush I begin shading the oranges to bring out their form, by adding violet, vermilion, and French green to the original orange color. The grapefruit comes next, and with the same brush, I dip into Prussian blue, alizarin crimson, and the lemon used for its flat local color. The shadow on the basket consists of the original mixture (yellow ochre and burnt sienna) plus ultramarine blue and violet—and a touch of the orange color as the shading nears the orange on the right. Now I further emphasize the lights on the oranges and the grapefruit by wetting the respective areas with the No. 6 bristle bright and removing most of the pigment with a folded paper towel—just as we did when working in transparent watercolor.

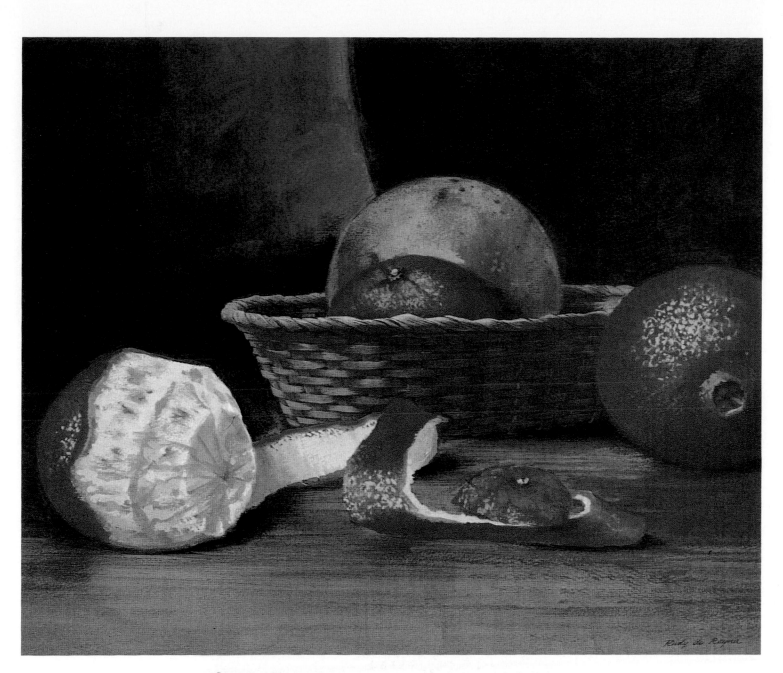

Step 5. After tapping a wet sponge on the grapefruit, I give the shadow a thin coat of yellow, yellow-green, orange, and a touch of violet with the No. 5 watercolor brush. While still wet, I hold the board in a flat position and with the tip of the brush, charged with burnt sienna and raw umber, I dab on the specks and spots. Now using Indian yellow, yellow, orange, Prussian blue, and white (included in the box) I do the lights on the oranges. Then, I mix orange, vermilion, and violet for their shadows. The basket comes next using the No. 3 brush and white, Indian yellow, and whisper of blue-green for the lights. Then, to this mixture I add orange, violet, cobalt blue, and blue-green for the shadows and to define the weaving. I move to the background and rub the side of a No. 7 watercolor brush with thin mixtures of cobalt blue, violet, and Payne's gray for the cool passages, and orange and burnt umber for the warm ones. I dip into the same puddles on the tray to strengthen the cast shadows on the table. To finish the table, I use Nos. 5 and 7 brushes and orange, vermilion, Payne's gray, black-violet, and white, applied in quick, horizontal strokes to render the grain of the wood.

6
Driftwood

Subject. Has it occurred to you that your friends probably have a number of highly "paintable" things, and that they would be delighted to lend them to you? I've painted pots, wheelbarrows, lobster traps, baskets, crockery, and candle holders—and countless other things that would fill a barn. I'd been fascinated by this driftwood at a friend's casement window for a long time before I got a chance to borrow it. I was smitten by its interesting shape, beautiful texture, and weathered, muted color.

Brushes. Having studied the subject at my friend's house, I knew even before I set brush to board that its texture would be achieved mostly with dry and split brushwork. This of course meant I'd require pointed watercolor brushes for the greater part of the work, and they turned out to be: Nos. 2, 4, 6, and 7. I also employed a 1″ (2.5 cm) flat sable for glazing. Usually, I reach for a particular brush as the need arises.

Other Tools. Again, I never knew what unorthodox tools I'd use until the picture was finished. They were: a toothbrush, a mat knife, typewriter paper, and matte fixative. Matte fixative is an aid I had never used before. It's used as an isolating agent to protect a certain stage in a painting so that subsequent work will not disturb the underlying layers of pigment.

Palette. It's almost inconceivable that a painting so restrained in color would have required so many colors. At first glance the colors are almost monochromatic, but the transitions from warm to cool passages are so subtle that I found myself dipping into: flame red, burnt umber, raw umber, raw sienna, yellow ochre, cadmium orange, brilliant yellow, alizarin crimson, permanent green deep, permanent green light, ultramarine blue, cerulean blue, cobalt blue, black, and white.

Painting Surface. The illustration board is Crescent No. 112 because its rough surface facilitates the rendering of the driftwood texture. This, and the Bainbridge No. 80 are two of my favorites because their surface papers are ideal for my way of working in opaque pigments, or combinations of transparent and opaque.

Medium. I'm always surprised to learn (at the workshops that I sometimes conduct) that opaque watercolor is not as widely used as it deserves to be. Especially since opaque has most of the virtues of transparent watercolor plus the tremendous advantage of letting the painter articulate detail lighter than the ground upon which it is done.

Painting Tips. It would be a good idea to paint with your hand resting on a mahlstick. If you're unacquainted with this practice, it may feel awkward at first but in no time at all it'll become second nature to you. One can of course rest a hand on a piece of paper placed over the painting itself, but there are times when a certain area (the sand, in this instance) is so fragile that the lightest pressure would disturb it. Fixatives claim to be nontoxic, but to eliminate whatever risk there may be, it's advisable to use them outdoors. For drybrushing, be sure to use very thin paint and to *fan* the brush as you empty it on a blotter or a paper towel. The *split* brush is obtained by charging it with color and then pressing it down to the ferrule on the butcher's tray until the stock separates into groups.

Sketch. When composing a picture I always keep an eye on the geometric shapes that the elements themselves create, because I believe that a realistic painting based on an abstract arrangement gains in animation and vitality. I did this sketch cognizant of the subject's form, color, and texture, but also keenly aware of the interesting arrangement of positive and negative shapes (positive shapes are those of the object itself—negative shapes are the areas surrounding it) so enticingly combined. The sketch is done on a 3-ply Strathmore "kid" (fine tooth finish) surface board. I used the Pelikan color box, a No. 6 bristle bright for the bulk of the work, and a No. 4 watercolor brush for detail.

Step 1. It was my original intention to enlarge the working drawing to the same proportions as the sketch, which is a vertical rectangle measuring 11″ x 8½″ (28 cm x 22 cm). But on second thought I decided that a format closer to a square would suit the subject much better. As a result, I did the working drawing on tracing paper with an office pencil, measuring 14″ x 15¾″ (36 cm x 40 cm). I check the sketch as well as the driftwood itself for the necessary modifications, not just in the contours, but also taking care to make the negative shapes as interesting as possible.

Step 2. If any of the following demonstrations begin in any other manner than by tracing the working drawing, I shall describe the method. But to avoid repetition I shall henceforth take it for granted that the procedure needs no further explanation, and I will leap immediately into the painting techniques. First, I mix in a nesting cup a very thin mixture of raw sienna, ultramarine blue, and black. Before spattering, I lightly tape a piece of 8½″ x 11″ (22 cm x 28 cm) typewriter paper, trace the drawing of the cast shadows, remove it, and cut the shapes out with a mat knife. I tape it back in position—the shadow area is the negative space. Then I dip the tip of the toothbrush bristles in the cup and scrape them against the edge of a piece of cardboard, aiming at the cut-out shapes to get the spatter effect.

Step 3. After removing the template I continue spattering over the rest of the painting with the same mixture, this time getting indefinite transitions between lights and darks. Then I mix in another nesting cup, mostly white with a spot of raw sienna and again scrape the toothbrush (after washing it thoroughly) for the light spatter over the dark one. As I do this I'm consciously trying to make the foreground sand coarser by not getting too close to the surface. I'm reaching for the correct texture of the sand by spattering light over dark and dark over light. At this stage the tones may need to be deeper or lighter but I can better judge possible changes after I've indicated the driftwood.

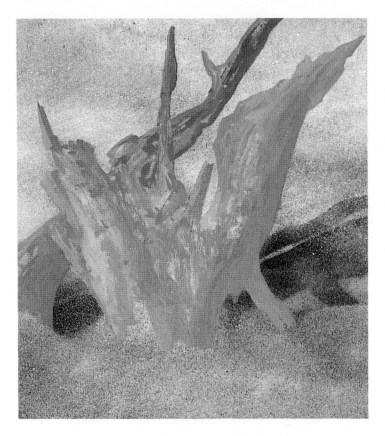
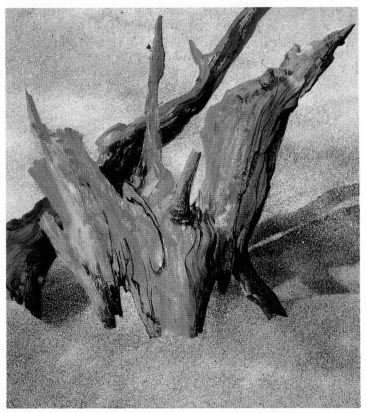

Step 4. I feel that the picture should be warmer to convey the feeling of sunlight. But instead of spattering yellows over the whole blooming thing I'll isolate the sand with a coat of fixative (let paint chemists shudder but I must take the risk) so I can glaze without dissolving and blurring the spatter. Then I pour water in a small white dish, add yellow ochre, and stir it with an old brush; into this yellowish water I dissolve whispers of raw umber and permanent green dark. With a fully charged 1″ (2.5 cm) flat watercolor brush, I begin glazing from top to bottom in long horizontal strokes while holding the board almost flat so the glaze won't streak down. More light spattering comes next, intermittently adding cerulean blue, alizarin crimson, and brilliant yellow to the mixture in the cup. With the point of a No. 7 watercolor brush I work the contours of the wood, and then scrub its side within the forms, using flame red, cadmium orange, raw sienna, cobalt blue, and white.

Step 5. Referring to the sketch as well as to the actual driftwood, I'm beginning to define detail and to establish some of the darkest values. I'm using the No. 6 watercolor brush with a mixture of black, burnt umber, raw umber, raw sienna, cerulean blue, permanent green deep, and white—executing details with the point, and drybrushing the rest with my hand resting on a mahlstick. I'm mixing the color on the butcher's tray, and doing the darkest darks with burnt umber and ultramarine blue, or permanent green deep and black.

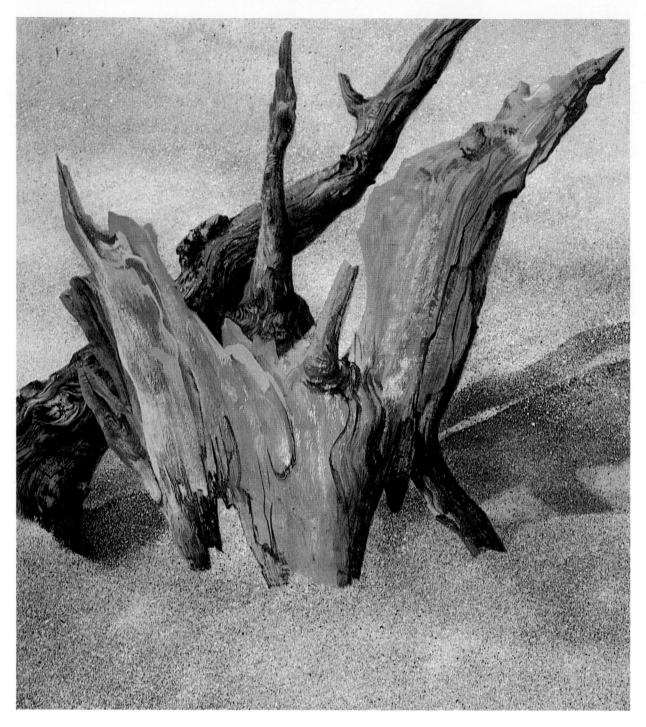

Step 6. I continue drybrushing and detailing with No. 2 and No. 6 brushes, using brilliant yellow, permanent green light, flame red, ultramarine blue, alizarin crimson, yellow ochre, burnt umber, black, and white. Notice I'm finishing the wood from the back pieces forward so I can slightly overlap the shapes in front, which will be "cleaned up" when I put the last touches on the main piece. I'm following the sketch's strong definition of form because the direct outdoors sunlight brought it out sharply, while the studio's north light reveals it much more softly.

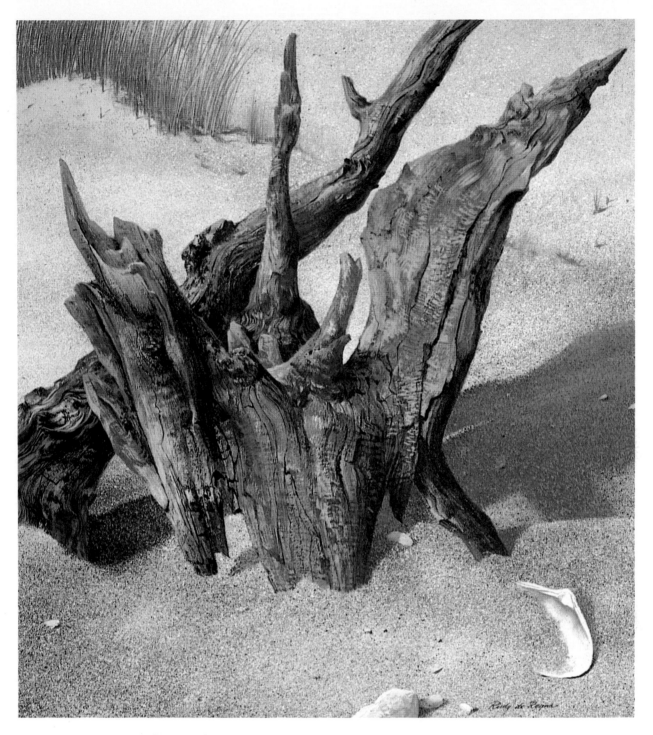

Step 7. By this time the tray is fully covered with the mixtures I've been using, so I just dip into them with the No. 6 brush for the broad modeling in sweeping strokes and the No. 2 for tiny details. When the wood is finished, I stipple the cast shadow with the No. 6 to retain the granular texture. Now I notice that the picture is a bit bleak, so I add the grass, the shell, and some pebbles, by sketching them first on a sheet of acetate taped over the painting. I use the acetate as a test material; when not satisfied with the size or placement I wash the drawing off and try again. Then with tracing paper over the acetate, I trace the subjects, remove the acetate, and transfer the drawing. For the grass, I use the No. 2 brush with a mixture of raw sienna, burnt sienna, yellow ochre, flame red, cerulean blue, and white; the shell (after scraping the spatter with the razor blade) with Nos. 2 and 4 brushes, using white, cerulean blue, raw umber, and whisper of flame red; for the pebbles, the same brushes and the same colors and there you are—with another masterpiece in your hands.

7
Snowbound

Subject. Please mark this well because the compensations are beyond belief: Your television set is a treasure chest replete with ideas for paintings. I was watching a news program when the scene sketched here was flashed for a few seconds. Quickly I did a pencil scribble and dashed to the studio to translate it into paint while it was still fresh in my mind. What intrigued me was the almost nonobjective arrangement of the light and dark shapes against the middle value of the trees.

Brushes. Keep a good supply of brushes because if there are paintings that require no more than one—as in the first demonstration—there are those that call for six, nine, and quite often even more. Even though this book deals only with water-soluble paints, you should have some bristle brights and flats because some things can be more easily rendered with them than with the conventional pointed brush. The brushes I used here were: No. 6 bristle bright, No. 12 flat sable, and Nos. 1, 2, 3, 5, 6, 7, and 10 watercolor brushes.

Other Tools. Aside from the essential materials of paper, paint, and brushes, there was no need to introduce any other tool.

Palette. There are more colors in this almost monochromatic picture than meet the eye. Even though I leaned heavily on the earth colors—raw and burnt sienna, as well as burnt umber, I was not niggardly with alizarin crimson, cadmium red, flame red, ultramarine blue, cerulean blue, permanent green deep, permanent green light, and just to keep it all in the family—permanent white by Winsor & Newton, instead of the Rich Art white that I use most of the time.

Painting Surface. Once more the rough surface of the Crescent board No. 112 proved ideal for the scrubbing and scumbling I did in both the underpainting and the painting of the band of trees in the background. It was also suitable for the modeling of the snowdrifts, and yet, rough as it is, it allowed the articulation of the minutest details—like the hinges, the mullions on the windows, and the slenderest twigs.

Medium. One of the many advantages of Winsor & Newton Designers Gouache tubes is that each one is labeled with either the permanence or fugacity of the paint. The fugitive colors are to be avoided when we indulge the notion that we're painting for posterity but they're perfectly suited for advertising art and illustration. After all, when the work is reproduced, they can, like old soldiers just fade away.

Painting Tips. If after practicing with a mahlstick—or an 18″ (46 cm) or 24″ (61 cm) ruler—it still remains a nuisance, then try a bridge, which is simply a ruler with ½″ (1.3 cm) thick 1″ x 1″ (2.5 cm x 2.5 cm) pieces of wood attached (taped or nailed) to each end. It is positioned over the painting with the ends placed outside the picture area, so that you can rest your hand on it instead of on the work itself. If I insist on a contrivance that will help keep your hand off a picture, it's because I feel it's absolutely essential.

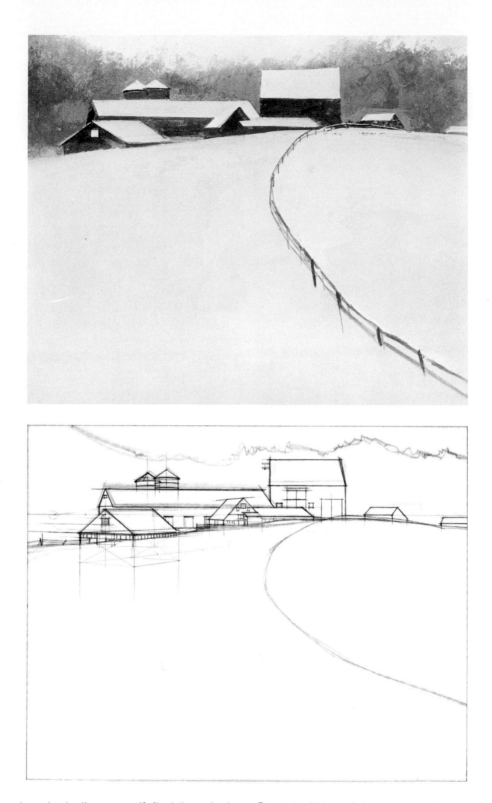

Sketch. (Top) Many artists, including myself, find the television an inexhaustible source of ideas. But not knowing enough about photography to take pictures from it myself, I'm reduced to dashing off embryonic pencil roughs, hoping that eventually they become full-fledged works. Sometimes it happens, as in this case, but I must confess that scores of them end up in the wastebasket. No loss, really, because even without fruition, they served to excite my imagination and to sharpen my memory. Do try it yourself next time you watch the telly. Keep a pad and pencil ready—or a camera poised if you prefer—and whenever anything comes on that strikes a cord, scribble it, or photograph it.

Step 1. (Above) Let me point out now that if the tonal scheme is not established in the sketch, I wouldn't be able to judge from the line drawing alone the proper emphasis and the balance of the elements in the painting. The line drawing—or the working drawing as I prefer to call it (I trace it to a support and oftentimes retrace it when it gets vague or lost while painting)—is an enlargement of the sketch with the necessary corrections and refinements to create a rhythmic composition. This one, on tracing paper with the No. 2 office pencil, is 16″ x 20″ (41 cm x 51 cm) enlarged from the 6″ x 7½″ (15.2 cm x 19.3 cm) sketch.

Step 2. (Top) I press a ¼″ (.64 cm) of burnt umber and ultramarine blue from their tubes. Then I wet a sponge (a crumpled paper towel works as well) in the water jar and squeeze some of it over each color and the rest in the corner of the butcher's tray because I'm about to use very thin paint. Thoroughly soaking the No. 6 bristle bright brush in the water on the tray I stir part of the umber and repeat the procedure—without rinsing the brush—with the ultramarine blue. From the puddle formed between the two colors I pick up a full load, and with the width of the brush held vertically I scribble the band of trees in up-and-down strokes.

Step 3. (Above) After squeezing raw sienna and permanent white on the tray, I dip into the ultramarine blue and burnt umber puddle (still on the tray from the previous step) with the No. 12 flat sable. Then with the same brush I dip into the raw sienna, and pick up a good wallop of white to mix the blue-gray for the sky. I spread the thin color quickly in crisscross strokes, painting into the band of trees so that later I can define the lacy contour of twigs over the sky. I take care not to mix the color thoroughly so that it remains "broken" with hints of cool (blue) and warm (sienna) passages.

Step 4. (Top) I add cerulean blue to the colors on the tray. Next, I charge the No. 6 watercolor brush with a mixture of all the colors and rub its side (holding the brush under the palm—a stabbing motion) over the trees. This allows some of the dark underpainting to show through the thin veil and gives me the effect of leafless winter woods. Some of the contours of the buildings are getting vague but I can still see them. If they get completely lost I'll retrace them with the working drawing. So far I'm just trying to get the character of the bare trees without attempting any detail yet.

Step 5. (Above) I move to the barns and sheds with the No. 6 brush, using washes of ultramarine blue, raw sienna, permanent green deep, alizarin crimson, and burnt umber. The red spot on the door showing above the roof is cadmium red. As I apply a cool (blue and green or blue and crimson) mixture to the buildings, I stipple a warm one (umber or sienna) over it to variegate it and keep it vibrant, instead of the dull and dead tone that would result if the colors were to be mixed beforehand. The color here is as thin as water, and with no white added.

Step 6. (Top) Even though I want to lead the eye to the motif at the upper part of the picture, I feel that the demarcation between the foreground and the center of interest is too abrupt, so I indicate a few rocks to make a more gentle transition. I paint the rocks with the No. 7 brush, using ultramarine blue, raw sienna, permanent green deep, and burnt umber. Stepping back to evaluate what I've done so far, I notice that the picture is too warm, which is a contradiction to the subject. I decide to give the snow areas a wash (tinted water actually, mixed in a dish and tested on the margin of the paper) of permanent green deep, ultramarine blue, and raw sienna, using a 1″ (2.5 cm) flat watercolor brush on the foreground, in horizontal back-and-forth strokes, working from the top down. Then I switch to the No. 7 brush for the roofs. The fence comes next and I tentatively indicate it with the No. 2 brush.

Step 7. (Above) I go back to the band of trees and push them closer to completion before cleaning up the roofs. With the tip of the No. 2 brush for branches and twigs and the side of the No. 6 for scumbling the larger masses—I use a mixture of ultramarine blue, burnt umber, alizarin crimson, flame red, raw sienna, and white. I'm referring to three sketches done the previous winter and to four Instamatic snaps taken sometime ago. Still skipping the finish of the barns I begin to indicate the snow drifts by scumbling with the side of the No. 10 brush charged with mostly white and tinted with ultramarine blue, cerulean blue, alizarin crimson, and raw sienna. The paint is very thin, mixed on the butcher's tray as I proceed. Then with the No. 2 brush I do further work on the fence, using ultramarine blue and raw sienna.

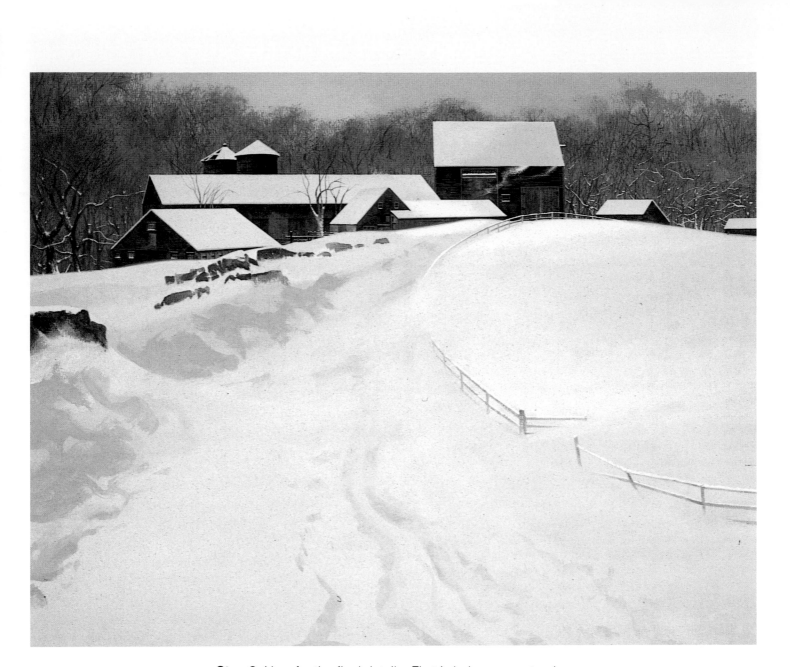

Step 8. Now for the final details. First I darken some trunks and branches with ultramarine blue, burnt umber, burnt sienna, and white, using the No. 2 brush. Next, I mix white with touches of permanent green deep, ultramarine blue, and raw sienna in a nesting cup for the snow on the trees. I apply the same mixture, using the ruling method, on the roofs with Nos. 3 and 7 brushes. Needing a larger red note, I move the door to the right. I go on to all details on the buildings with a No. 1 or a No. 2 brush as I need it, dipping into the ultramarine blue and burnt umber, and then mixing flame red and burnt sienna for the door and the long window under the eave. With the No. 3 brush, I clean up the crest of the hill next with the tint used for the roofs. I transfer part of this mixture to the tray and after deepening the value with cerulean blue and alizarin crimson, I define the snow drifts, darken the right side of the roof on the tall barn, as well as the left side of the one against the long barn. Dipping again into the original roof mixture I render the wind-blown snow with the tip and side of the No. 3 brush. I give the drifts their final shapes with Nos. 5 and 7 brushes and while doing this I remove the tall pole supporting the gate because it made an awkward triangle. I then decide to introduce some trees among the barns to relieve the severity of the long roof. Last touches are on the fences with Nos. 2 and 3 brushes, using pure white and the dark mixtures still on the tray.

8

Lee's Rock

Subject. I doubt if there is anyone who is left unimpressed by the turbulence and immensity of the sea. Some painters devote their lives to it, and others periodically stray into other themes only to return to it with renewed fervor. Could it be that dim echoes still linger in us of the sea-doggery days of our ancestors? Or perhaps the stirring tales of Conrad, Stevenson, London, Hugo, and Dana pull us to the setting where so much drama has unfolded. Whatever the reason, I love to paint it, but, landlubber that I am, the views are usually from the shore. This one is a combination of an Instamatic snapshot of the sea at Truro on Cape Cod, framed by rock formations I sketched at Ogunquit, Maine.

Brushes. Most of the time when I want to cover large areas I pick up a No. 20 or a No. 22 flat sable, but in this painting I chose a 1″ (2.5 cm) flat watercolor brush because its long hair allows gentler stroking without the risk of disturbing an underlying color. After checking my notes I see that the other brushes were: a No. 20 flat sable, and Nos. 2, 3, 5, 6, and 7 pointed White Sable watercolor brushes by Robert Simmons.

Other Tools. Even while sketching these rock formations in Ogunquit I knew that if and when I painted them I'd use a painting knife for their initial lay-in. It is an indispensable tool when underpainting things of this sort, not just to achieve the texture and character of rocks but also to get the cracks and configurations that the painting knife will form by chance. The other items I've introduced are Liquitex Matte Medium to isolate the underpainting of the rock formations and some paper towels.

Palette. The palette consists of the reds, yellows, and blues that I employ when painting any subject: alizarin crimson, burnt sienna, and burnt umber; yellow ochre and raw sienna; ultramarine blue, cobalt blue, and cerulean blue; plus permanent green deep and white. I must mention that in every passage I try to obtain the color I want with mixtures of only alizarin crimson (which is the true red—not the red-orange we've come to call by that name), yellow ochre, and ultramarine blue. It's only when I need higher intensities or cooler or warmer color that I resort to others.

Painting Surface. The first two qualifications I look for in any support are texture and thickness. There are other considerations of course—the paper's tolerance to light, and whether it can take the ruthless punishment some paintings call for. But primarily I'm concerned with the smoothness or the roughness that will help me get the desired textures in a particular work. Here, for example, the Crescent illustration board No. 112 rough was ideal for the rocky areas, while giving me no trouble in rendering the smoothness of the sand or the luminosity of the sky.

Medium. Even though sometimes I use Grumbacher's Designers' Gouache Watercolors, I find myself constantly reaching for the Winsor & Newton's tubes of Designers' Gouache because of their intense brilliance and marvelous opacity. I don't know what binding vehicle they contain but I can rely on it for the most watery washes to adhere, or the thickest impasto to remain uncracked—provided of course the support is thick enough not to bend.

Painting Tips. When, in step 7, I changed the contour of the rock touching the bottom border, I made a notation to remind you not to hesitate to change anything that's not completely satisfactory. As a student, I remember leaving many things that bothered me but didn't dare touch them for fear of making a hash of it. Well, don't be afraid. After all, whatever one says pictorially should be the best statement one can make. Another tip I'd like to share is to put your fingers to work as painting tools. Nothing new, Titian used his fingers more than his brushes in the last stages of his career—just make sure that whatever paints you use are nontoxic. I used my middle finger when rendering the rocks.

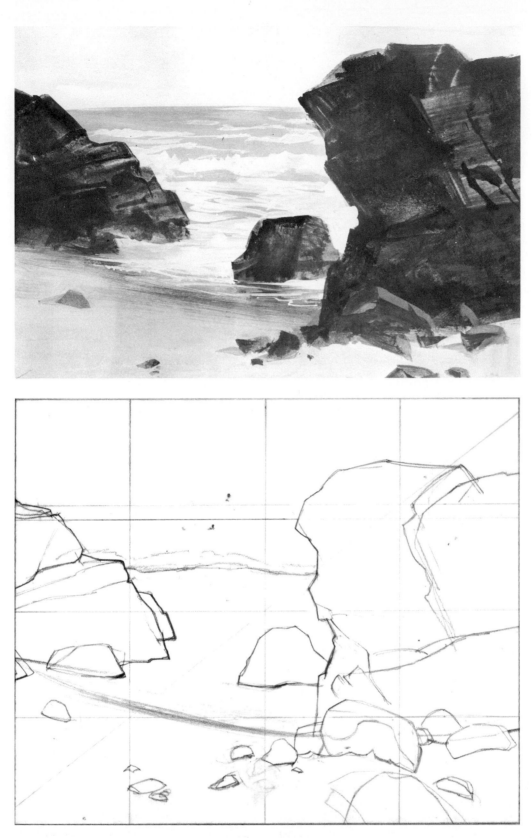

Sketch. (Top) "One swallow maketh not summer," said the sage long ago. If I may ape the observation: One study doesn't make a picture—because one source of information is not enough to make a convincing pictorial statement. This sketch is a combination of a snapshot and two studies. Each one is valuable as a reference but unable to say anything artistically. It is only when grouped together, like words in their proper syntax, that they make sense. In this instance I felt I should push on and attempt a finished painting. So, gather your snapshots and sketches of sea and shore, group them into a telling synthesis, and paint along with me.

Step 1. (Above) In the drawing I try to reinforce the linear harmonies roughly indicated in the sketch. For example, the rock formation on the left serves as a "pointer" into the picture, but its thrust is stopped by the vertical contour of the mass on the right. Note also that this line doesn't stop abruptly as it strikes the beach, but continues in a broken movement made by smaller rocks to subtly lead the eye back to the sea, which in turn is framed by the two big shapes. I mention these things because no matter what the theme, it deserves the best composition we can arrange.

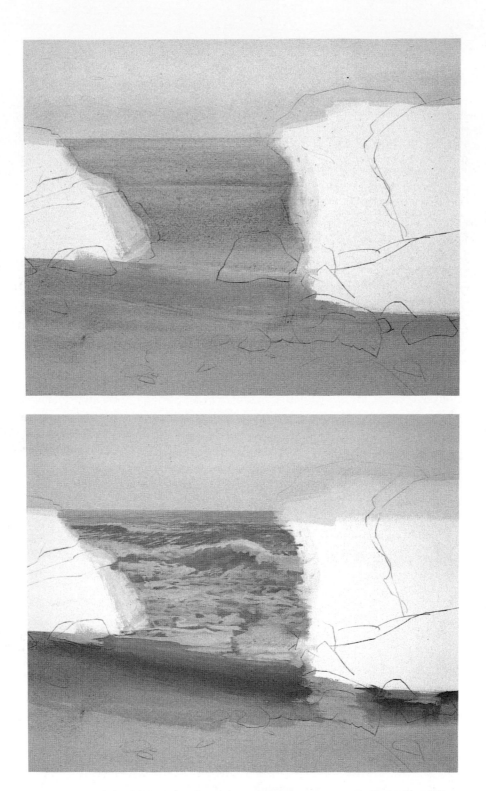

Step 2. (Top) Resting the top edge of the illustration board on the drawing table and holding the lower edge in my left hand, I apply a very thin wash of raw sienna with the 1″ (2.5 cm) flat brush in back-and-forth horizontal strokes. The board is almost flat but tilted slightly toward me so that the wash glides downward. I recharge the brush often so that its full load can go the full width of the picture, which is 18″ x 15″ (46 cm x 38.1 cm). While the wash is still wet I tap a folded paper towel across the upper portion of the sky, bringing it back to almost the pure white of the paper. This is another way of getting a graded wash. Next I paint in the beach with the same brush, after adding cobalt blue to the raw sienna puddle on the tray. I move over to the sea and give it a wash of cobalt blue with a touch of raw sienna, still using the 1″ (2.5 cm) flat brush. After rinsing and wiping the brush I use it to pick up some of the color while it's still wet.

Step 3. (Above) Back to the sky with the 1″ (2.5 cm) brush; on the tray I dilute a very thin mixture of cerulean blue with a touch of yellow ochre, and a spot of white. As I descend, again in horizontal back-and-forth strokes, I add more water to further dilute the pigment and allow the warm underpainting to show through at the horizon. Then I do the first indication of the sea, dipping the No. 7 White Sable brush into nesting cups containing cobalt blue, yellow ochre, burnt sienna, and white. I mix the tints as I go, holding the brush vertically under the palm and tapping its side across the horizon. Then I switch to the No. 5 brush and add more cobalt blue, yellow ochre, and burnt sienna to the white to get the deeper values I need as I work my way down toward the beach.

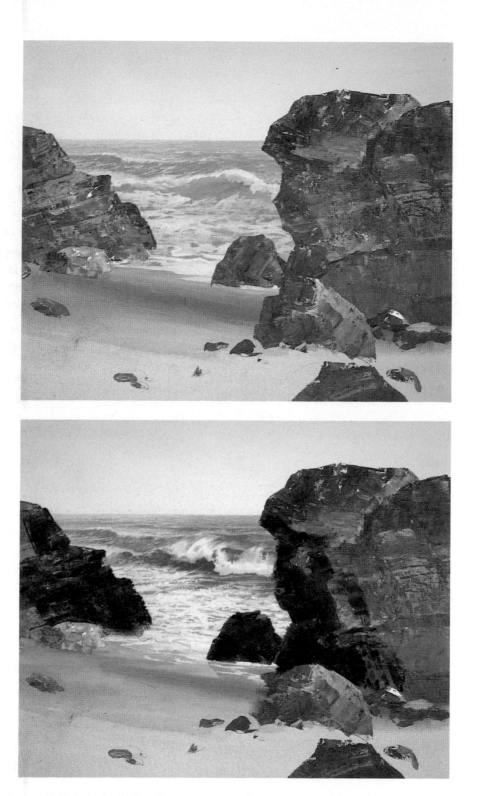

Step 4. (Top) I press about ½″ (1.3 cm) of alizarin crimson, raw sienna, ultramarine blue, and about 2″ (5.1 cm) of permanent white right on the tray itself. Then, with the 2¼″ (6 cm) trowel-shaped painting knife, I pick up varying quantities from all three colors and the white, mix the colors loosely on the tray, and then spread the mixture on the rocks with the edge of the blade. If an area gets too warm, I spread some blue over it while the paint is still wet. The combination of the thick paint and the rough surface of the paper gives me the texture I want.

Step 5. (Above) Dipping into alizarin crimson, burnt umber, permanent green deep, and ultramarine blue with the No. 20 flat sable, I mix a glaze of mostly water and apply it only to the rocky edges adjoining the sea. This way I can judge better how dark to make the lower values on the water and still keep them in the distance. Now starting at the horizon with the No. 2 brush and using cobalt blue, yellow ochre, and white I begin defining the sea. When I reach the crashing wave and the foam I switch to a No. 3 brush and add permanent green deep and alizarin crimson to the colors mentioned above. Then, using the No. 6 brush I do the dark, wet edge of the sand. Notice I'm slightly overlapping the water into the rocks because I can easily regain their edge with this opaque medium.

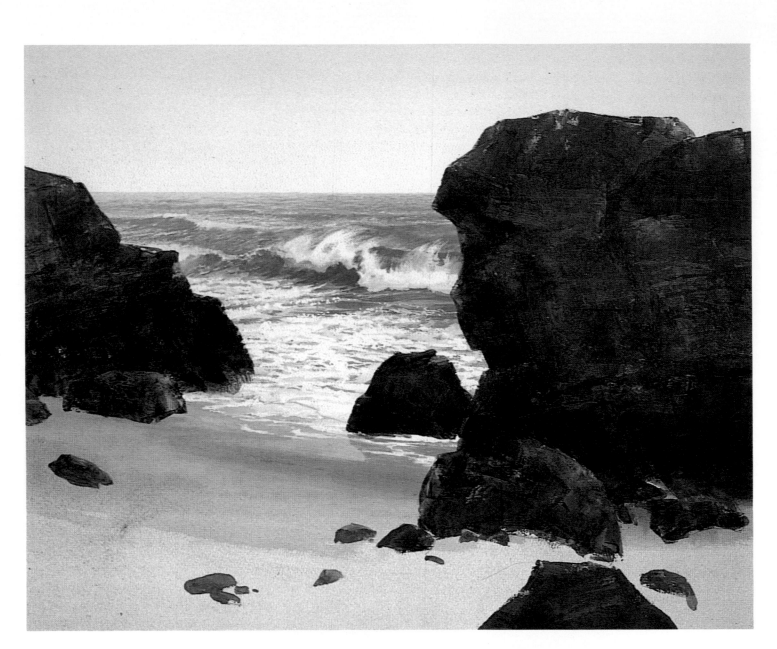

Step 6. I continue glazing the rocks with the No. 20 flat sable but not before giving them a coat of Liquitex Matte Medium, so that the thick color and protuberances left by the painting knife will not be smudged or disfigured. It is unusual for me to introduce anything foreign to the medium itself. Although I have glazed successfully (the sky in this picture for example) without isolating the undercoating, this time I didn't want to take the chance of losing some of the happy accidents provided by the knife. The colors that I float with the No. 20 flat sable are: alizarin crimson, raw sienna, burnt umber, ultramarine blue, and permanent green deep. Then, adding white to the same colors I paint the small rocks on the beach with the No. 3 brush.

Step 7. So far I've been preparing the ground for the final details. I begin with the lightest lights on the wave and the foam with tints of ultramarine blue, raw sienna, permanent green deep, and white—using Nos. 2 and 3 brushes. Then I mix as I paint the blue-greens and green-blues of the sea. With the same colors and brushes, using their tip and side, I do the detail on the rocks. When something becomes too sharp or obtrusive I subdue it by tapping or rubbing my finger over it. Next, with the No. 7 and the same colors, I dry-brush the dark wet shape on the beach and paint solidly the rest of the sand, working it slightly into the smaller rocks and then regaining the rocks' shapes with their local color. Then I finish the rocks on the left and in the foreground with the same brushes using alizarin crimson, raw sienna, ultramarine blue, and green deep—not a mixture of the colors but scumbling and glazing blues over reds and reds over blues and violets. Not satisfied with the rock on the bottom border, I scrape off the left side with the razor blade and repaint it because it was too symmetrical and uninteresting.

9
Bread and Wine

Subject. When a friend, after a holiday in Italy, informed me that the traditional straw cradle of the Chianti wine bottle was being replaced by a plastic contraption I dashed over to the wine shop and bought three of them. I chose the largér one to paint because it was the right size in conjunction with the loaf of bread, the knife, and the glass. As I did the sketch from the group set up in the studio, I became aware of the variety of textures—plaster, steel, bread, glass, straw, wood, and cloth. So it follows that we should make this a study of the tactile qualities of the elements in the picture. Take time to feel them as you arrange your group, and then imagine as you paint that you're touching them again—it will help you to render them more realistically.

Brushes. Here again, with the exception of the No. 22 flat sable by ArtSign, the No. 20 flat red sable and Nos. 1, 2, 3, 5, and 6 pointed White Sable brushes are by Robert Simmons. This new synthetic fiber is the latest challenge to the supremacy of the red sable, and in my opinion it may well become the new champion. You'll be surprised at their flexibility and point retention, not to mention their lower price.

Other Tools. It's understood that when working realistically, anything can be rendered, or any effect achieved by the brush alone. When other tools are introduced it is merely to expedite the job and perhaps in the process to create, quite by chance, the unplanned or unforeseen results that we've come to call "lucky accidents." Here, for example, my powers of invention would have been strained trying to create the shapes and ridges on the plaster wall that an expired credit card automatically made as I applied the Liquitex gesso. Or imagine the tedious job of rendering the texture and the hollows of the cut bread without the aid of a sponge, which got the job done in half a tick by merely tapping it with the required color. In place of a credit card you can use cardboard, and I know there's a synthetic sponge somewhere in your house. If there's no gesso, use acrylic titanium white.

Palette. When I begin a painting I haven't the vaguest idea what colors will be needed, so I keep in stock a wide range of reds, yellows, and blues. It's much better to have a large supply than to stop in the heat of creation to go to the shop, miles away. One reason I list the required colors for each work is so you'll know what's needed before starting to paint. Check your supplies and make sure you have: Hooker's green dark, cadmium red light, yellow medium azo, yellow oxide, burnt umber, titanium white, phthalo blue, ultramarine blue, naphthol itr crimson, cadmium yellow light, dioxazine purple, cadmium orange, and burnt sienna—all by Liquitex.

Painting Surface. I wonder why manufacturers don't put colored illustration boards on the market, as they do colored mat boards. It could be that they leave it to the artist to undercoat any board with whatever tint or shade desired for a particular work—especially when working in acrylic. But what about the lazy blokes like me who'd rather have everything ready-to-use and not have to bother with messy preliminaries before beginning to paint? I am thankful, however, that there is a wide range of colored mat boards—even if their surface paper is not sturdy enough to withstand the razor blade, or repeated wettings that might cause "blistering." I've chosen the Bainbridge "tan" board No. 758 because it lends itself to the overall color scheme.

Medium. For this demonstration and the next three, the medium will be acrylic. I doubt if there are any painters today who haven't tried acrylic. Though some, after trying it, quickly return to whatever medium they feel comfortable in—myself included. But after further experimentation I discovered so many marvelous qualities in the stuff that I'm glad I persisted. It handles like transparent or opaque watercolor, depending on the consistency, with the added advantage that once it dries it becomes insoluble and will take glazing without having to isolate one film of color from another. And it dries, unlike watercolor, in the same color and value as when wet. I've done this first picture employing direct painting and glazing combined.

Painting Tips. Many artists discard acrylic before discovering its full potential since it doesn't behave like any traditional media. Let me make these suggestions: (1) Press only small amounts into wet nesting cups and cover—with another nesting cup—whatever color not in use. Squeeze a drop or two of water from a sponge or a paper towel on color that begins to dry. (2) Robert Simmons White Sables are ideally suited to the medium. (3) Use a shallow jar so that the brushes are rinsed to the heel, where pigment accumulates. (4) A butcher's tray is the best palette—the larger the better. When the mixtures dry, rub a wet paper towel over them to break up the films of pigment, then remove them with a palette knife and wipe the palette clean with a damp paper towel. (5) After painting wash brushes with lukewarm water and mild soap.

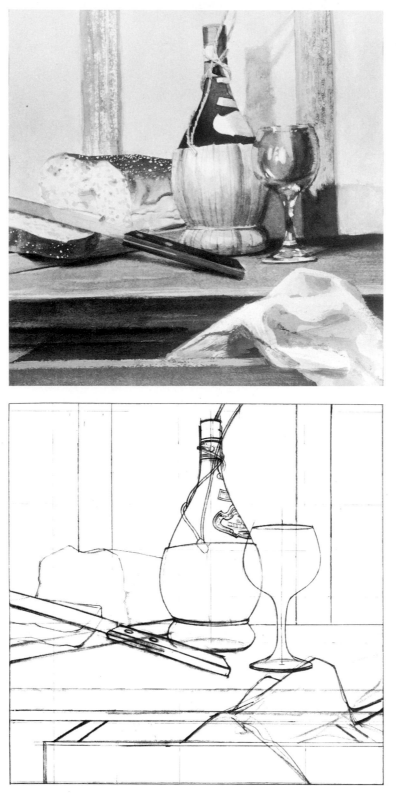

Sketch. (Top) I think that most students go out sketching too soon—long before their eye is taught to see and their hand trained to do. Their eagerness to capture nature's beauty is understandable—especially to me. I too, ventured out wholly unprepared, only to return consequently with very sad results indeed. I cannot urge you too strongly to set up still lifes as often as you can and paint away. Be sure that the light, natural or electric, remains consistent, and if a color or tone gives you trouble, try again checking the warmth or coolness, or the lightness or darkness of an area by comparing it with another area. Before long you'll be amazed at your technical proficiency.

Step 1. (Above) When drawing any symmetrical object like a bottle, a glass, a bowl or anything with equal right-and-left contours, I find it expedient to rough out the general shape first, throw a vertical center line, and then tape a piece of tracing paper over it. Next I do an accurate line drawing of one side of the object and across at top and bottom until they meet the center line, which I mark with a vertical hyphen. I remove the tape, flop the drawing, tape it again, erase the original rough, and trace one side with a 2H pencil. Then I flop it again and repeat the operation for the other side. The rest of the elements are enlarged by the squaring-up method to an area 14½" x 14½" (37.3 cm x 37.3 cm) from the 7¼" x 7¼" (19 cm x 19 cm) sketch. Remember that my sketches are usually smaller than the drawing even though they are shown here as the same size.

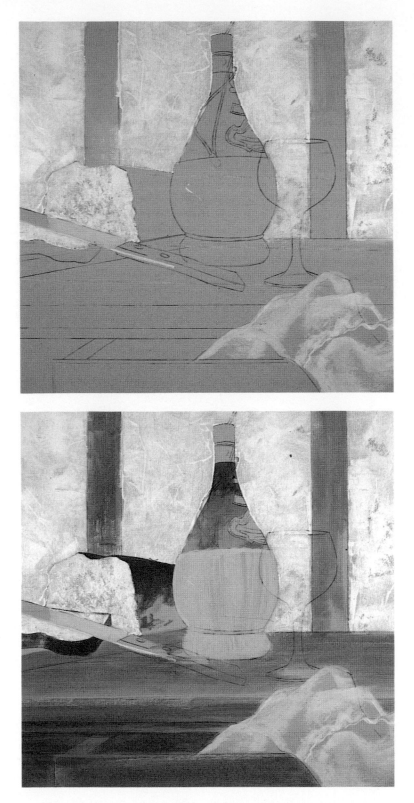

Step 2. (Top) After again setting up the still life for the painting, as I did for the sketch, I pour some Liquitex gesso in the butcher's tray. Then with the edge of the credit card I scoop up a portion and scrape it over the wall area, using the corner of the card to get into the small shapes. I move to the blade of the knife and give it a wash of titanium white with the No. 5 brush, to serve as a reflection of the bread. Then, with the edge of a ½″ (1.3 cm) synthetic sponge I pick up the undiluted white from the tray and tap it on the white of the bread, including the slice under the knife. After diluting some white to medium thick, I scumble the towel with a No. 5 brush. Keep in mind that I'm making use of the tone and color of the support by letting it show through wherever it serves my purpose.

Step 3. (Above) After squeezing a spot of Hooker's green dark on the tray I dilute it to a watery consistency with the No. 5 brush and apply it to the top of the bottle. Next, I press a ¼″ (.64 cm) of cadmium red light into a nesting cup, proceed to do the same with the yellow oxide and burnt umber, and then paint the crust of the bread with the same brush, using washes of all three colors. To render the straw cradle, I take a No. 20 flat sable and dip into the nesting cups containing phthalo blue, yellow oxide, cadmium red light, and white. With the same brush I move to the woodwork and give it a partial wash—leaving some of the board untouched, using burnt umber, yellow oxide, and ultramarine blue, but no white.

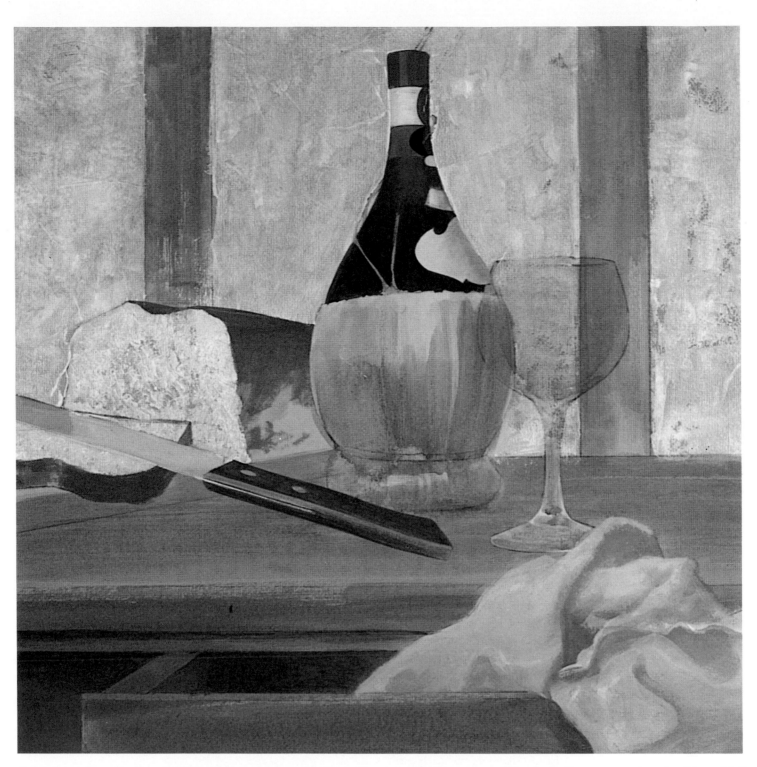

Step 4. I pick up the No. 22 flat sable and stir a watery wash of yellow medium and yellow oxide, tempered with a whisper of ultramarine blue and float it over the wall. To the yellow puddle on the tray I add more ultramarine blue and burnt umber and work it on the straw cradle, and continue with it for the darks on the counter. For the whites on the bottle, I use white and varying amounts of burnt umber, yellow oxide, and ultramarine blue, as they turn into the shadow. Then I trim them with the wine which is naphthol itr crimson (itr is darker), cadmium red light, ultra-marine blue, and white. I use the same colors for the red foil at the top and the red labels, with the No. 3 brush. Now I glaze the glass—after whiting out the counter across the stem—with burnt umber, yellow oxide, and ultramarine blue, using the No. 5 brush. Switching to opaque paint again, I work on the napkin with white and whispers of aliz-arin crimson, yellow oxide, and ultramarine blue. After adding burnt umber to the above colors, I paint the knife's handle.

Step 5. Constantly checking the still life before me, I paint the bottle's cast shadow with Nos. 5 and 6 brushes, using cadmium yellow light, phthalo blue, ultramarine blue, yellow oxide, burnt umber, and white. The same for the cast shadow of the glass. I pick up the No. 3 brush to work on the bottle's twine handle—using white, naphthol itr crimson, yellow oxide, ultramarine blue, and burnt umber. With the same colors and the same brush I do the linear articulation of the straw cradle, and the distortion of the slat seen through the wine glass. That blinking slat on the left has been bothering me for a long time; it breaks up the picture into too many areas of equal size. Wonder why I didn't notice it in the sketch, but I must remove it now.

Step 6. Now for the details. In the following order: (1) The labels on the bottle with cadmium red light and mixtures of alizarin crimson, ultramarine blue, and burnt umber, to make the black for the scroll and the lettering—using the No. 1 brush. I do the gold on the labels with Hooker's green dark, cadmium yellow light, yellow oxide, and white. Then the wine, the twine, and the scarlet top with alizarin crimson, cadmium red light, cadmium yellow light, yellow oxide, burnt umber, Hooker's green, dioxazine purple, phthalo blue, and white. (2) Dipping into the colors for the bottle I do the glass, developing sharp and soft-edge reflections, going all the way up to pure white, with the No. 2 brush. (3) With the No. 3 brush I modify the color of the crust and do the corrugations on the side of the bread with cadmium orange, burnt sienna, yellow oxide, cadmium red light, burnt umber, and white. Then I do the cut end with white, yellow oxide, burnt sienna, and ultramarine blue—and add more hollows, matching those originally left by the color of the mat itself. (4) Final definition on the straw cradle with the No. 5 brush and cadmium yellow light, yellow oxide, Hooker's green dark, burnt sienna, burnt umber, and white. (5) I deepen the left side of the counter with glazes of burnt umber and ultramarine, using the No. 20 flat sable. (6) I give the finishing touches to the napkin with alizarin crimson, yellow oxide, ultramarine blue, and white with the No. 6 brush, using thin as well as thick paint and taking care to convey, by its folds and its soft edges the pliability of cloth. (7) And last, the salt on the bread with white and yellow oxide, using the No. 1 brush—and then adding a touch of cadmium red light for the crumbs on the counter.

10
First Snow

Subject. There was a time when I thought the three most beautiful things on earth were a tree, a horse, and a woman—in that order, when I was only in my second of the seven ages of man. And my ambition was to stun the art world with my masterpiece of a Godiva creature astride a horse, against a willow. But childish things pass, and though I do not love them less, I love more the sea, and old boats and barns, and snow. Yes, especially snow—that beautiful nuisance.

Brushes. Because of the subject and the painting surface I chose, the brushes turned out to be a 1″ (2.5 cm) red sable, a No. 8 flat sable because it can soften an edge better than a round brush, and Nos. 1, 2, 5, and 6 pointed White Sable by Robert Simmons because this new synthetic fiber seems to be at home with acrylic.

Other Tools. No one can deny that a paper towel's job is to dry, or that a razor's function is to shave, except when an artist picks them up and makes them part of the equipment. In this instance I used the first to wipe off pigment, and the second to scratch it.

Palette. The somewhat limited palette here consists of the following Liquitex colors: naphthol itr crimson (darker than naphthol crimson), yellow light, yellow oxide, ultra-marine blue, burnt umber, Hooker's green, and phthalo blue, which the paint chemists persist in calling by the tongue-torturing name of phthalocyanine.

Painting Surface. Since more and more painters are using acrylic as transparent watercolor, I thought it a good idea to have a go at it in such a manner. That being the case it follows that I should have the best support available (no pun) so I chose a piece of d'Arches 140-pound rough watercolor paper for this 8¾″ x 10½″ (22.2 cm x 27 cm) painting.

Medium. I personally know artists who wouldn't touch acrylic with a barge pole. It is too filmy and rubbery and it dries much too fast, they say. Well, no one can argue that every medium has its limitations as well as its virtues. If acrylic dries too fast, then by the same token, oil dries much too slow. My purpose here is to extol its advantages, without overlooking its shortcomings.

Painting Tips. I must caution you again that when the razor blade is to be used while working in transparent acrylic color, the paper better be first-rate or the results will be disastrous. And in case you have a tendency to paint grass in downward strokes, I urge you to resist it and do it as it grows, from the ground up or the character will be lost.

Sketch. (Top) I think the next best thing to sketching from the car is sketching through a studio window. I would reverse the order were it not for the fact that the latter is restrictive to very few subjects. While viewing from a distance a job that was on the drawing table, I looked out the window and saw the scene that I sketched for this painting. I used the Pelikan color box, Nos. 1 and 3 watercolor brushes, and a Strathmore watercolor pad. The sketch measures 5″ x 6″ (13 cm x 15.2 cm). If there's no snow in your area then sketch whatever you see out the window right now; painting waits for no man or woman. Even if night has fallen, get your color box and begin because artists are not exempt from discipline.

Step 1. (Above) If I were to make some random marks on a piece of paper and throw in some blotches for good measure, by today's standards it would be called a "drawing." No quarrel with that. Artists who follow this mode of expression are as dedicated and sincere as we who revel in nature's handiwork and try to come as close to it as paint and pencil will allow. But specifically, when drawing rocks and boulders think of their bulk and weight—their height, depth, breadth, and the space they occupy. Do this with anything you draw and you'll come to the artist's truth, your truth.

Step 2. After tracing the drawing I tape the d'Arches paper to a piece of chipboard (any cardboard will do). Then I wet it with a synthetic sponge, tapping it more than rubbing it. I should mention that there's a generous margin all around of about 4″ (10.2 cm) or 5″ (13 cm), beyond the picture area. I begin to paint when the water stops glistening; otherwise, whatever mark the brush makes will spread beyond the shape I want. In a cup I mix ultramarine blue, yellow oxide, and a touch of burnt umber. Besides following the sketch, I occasionally look out the window to restudy the actual subject. I apply the first configurations with the No. 6 brush. When an edge comes off too hard, I immediately soften it with a damp No. 8 flat sable.

Step 3. Even though they might not show, I lighten the pencil contour of the rocks with a kneaded eraser because I don't like pencil outlines showing in a watercolor painting—a personal idiosyncrasy I suppose. Anyway, I pick up the No. 6 brush and dip into burnt umber, ultramarine blue, and yellow light—letting the cool or warm mixtures predominate for one or the other of the rocks—and I apply them to the dry surface. I use the side of the brush, except on the contours, to take advantage of the rough paper so that it conveys the harsh texture of the rocks. Also, I use the side of the brush to render the speckled lights on the rocks that will serve as part of the snow later. I'm diluting the paint to the consistency of watercolor.

Step 4. Now the main section of the rocks are established, I can begin indicating the grass. It may not reproduce but I've just given the entire picture (after again studying the actual scene) a very faint wash of phthalo blue and burnt umber with the 1″ (2.5 cm) brush, to suggest the diffused light of a sunless day. While the tint is still wet I pick up lights, with the edge of a folded paper towel, between and beside the ridges at the top of the picture. When the paper dries I begin indicating the grass in upward strokes with the Nos. 1 and 2 brushes, using mixtures prepared on the tray of ultramarine blue, phthalo blue, burnt umber, and yellow oxide.

Step 5. I'm still following the sketch closely; as a matter of fact, the sketch can rightfully be called a preparatory painting. Nothing new, really. Constable followed this procedure in his celebrated *Hay Wain* and in many other instances. But back to work. I use the No. 5 brush to render the rocks in their final darker tones, scumbling with the side, stippling by pounding it at right angles to the surface, and using the point to refine contours and shaded areas. The colors, mixed on the tray, are alizarin crimson, yellow oxide, ultramarine blue, and Hooker's green. Then, swinging freely, in upward strokes with the No. 2 brush I do the tall clumps of grass using burnt umber, yellow oxide, ultramarine blue, and Hooker's green. And last I do the stalks in the same colors and with the same brush. Working in transparent mixtures, they show only against the white, so I scratch them over the dark rocks with the corner of the single-edged razor blade.

11

Buttes

Subject. Some artists put their painting paraphernalia in the car and go off across the country, and sometimes into neighboring ones, in search of things that will move them to paint. How lovely it must be to scratch one's itchy feet like that, but since I can't, I must rely on the snapshots lent to me. Check your own photos and see if you have anything similar so we can do another transparent acrylic.

Brushes. One can of course use the round and flat sable watercolor brushes when painting in acrylic, but after purchasing a few Robert Simmons' White Sables, I now join the hymns of praise of all those who have tried them. I have used here Nos. 5, 6, and 10, besides the 1″ (2.5 cm) flat and the No. 20 flat sable, also by Simmons.

Other Tools. The only other tool used here was a soft Pink Pearl eraser to pick up lights on a dry surface. Kneaded eraser could have been used too, but since an acrylic film is tougher than a watercolor wash, it would have taken much longer.

Palette. The Liquitex colors this picture required were: naphthol crimson, cadmium red light, yellow light, yellow oxide, cobalt blue, phthalo blue, ultramarine blue, Hooker's green, and burnt umber. Even though I use Liquitex paints exclusively for these demonstrations it doesn't mean that I never use others. Grumbacher's Hyplar acrylics are fine quality colors too.

Painting Surface. When I mention a specific paper, Fabriano in this instance, and you don't have it in stock or it happens to be unavailable in your area, don't be discouraged from doing your appointed task. Other good names are Strathmore, Bockingford, Schoeller, and Saunders, to name only a few.

Medium. One can exhibit a painting done in acrylic washes as a transparent watercolor, but I always felt I was palming off something masquerading as one thing when actually it was another. And I wonder why there's no category called "transparent acrylic," which this painting is.

Painting Tips. I think the best tip I can give you as we work on the last of the transparent watercolor demonstrations is that you must be able to differentiate the degrees of wetness of the paper in order to achieve exactly the softness or the crispness of the edges you want. Do practice on pieces of scrap paper.

Sketch. (Top) Bless my friends who are always ready to send me whatever snapshots they think may turn out into a picture. I remember being awed by the sight of these majestic monuments, but God in heaven that was thirty-odd years ago, and as a rule I don't paint anything I'm not familiar with. Yet, I couldn't help making a tentative sketch, combining three of the snapshots, just to see if anything would happen. Well, as you see, nothing earth-shaking developed, but I decided to use it anyway for another transparent acrylic. The sketch is 4½″ x 5½″ (11.5 cm x 14.3 cm) and done with the colors of the Pelikan box on a piece of scrap paper.

Step 1. (Above) In case I haven't made myself clear, let me point out that this drawing is an enlargement in line of the elements in the previous sketch. After placing a piece of acetate on the sketch I draw a grid with a Stabilo pencil. Then duplicating the grid in whatever larger proportions I want I enlarge it on a piece of tracing paper and do the line drawing with an office pencil. I tape the drawing at the top of the painting surface, slip a piece of transfer paper between it and the drawing, and trace it, usually with a 5H pencil.

Step 2. I begin the warm overall color scheme by giving the sky area a graded wash of yellow oxide, tempered with a whisper of naphthol crimson. Starting at the top, I bring the wash down with a fully charged 1″ (2.5 cm) watercolor brush. The mixture is in the corner of the butcher's tray. As I descend I add more water and a touch of yellow light to make the sky warmer and lighter near the horizon. Even though the wash is applied to a dry surface the paper buckles a bit, but not to worry, it will smooth itself out when it dries.

Step 3. In a cup I prepare a mixture of naphthol crimson, yellow oxide, and cobalt blue, and test the resulting color on the margin of the paper; it turns out to be too warm so I add more blue. After rewetting the sky area with the 1″ (2.5 cm) brush I float the shapes of the clouds with the No. 20 flat sable, holding the paper (taped to a piece of chipboard) almost flat with my left hand as I work with my right. The paper is just wet enough to give me soft edges and to control the cloud shapes I want. When the paper is completely dry, I paint the distant horizon with the No. 6 white Sable.

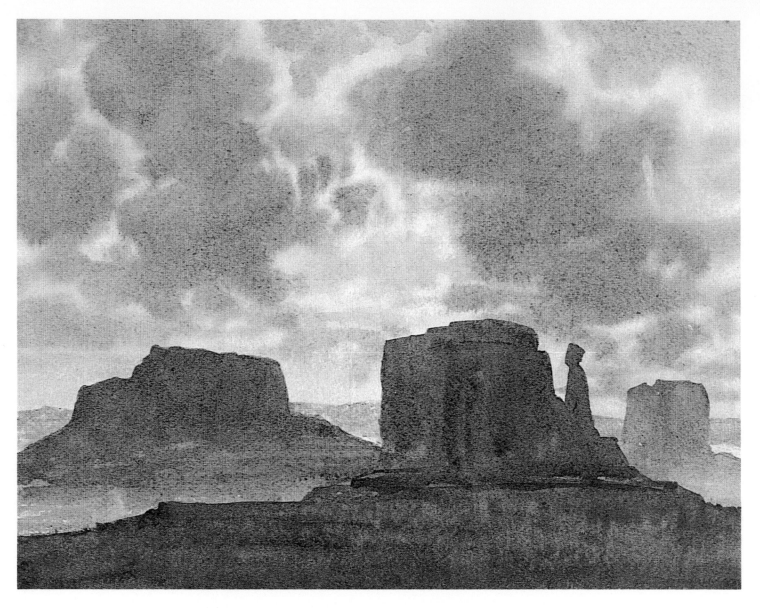

Step 4. Again I wet the entire sky and with the 1″ (2.5 cm) brush, I give it a flat wash of very diluted naphthol crimson and yellow light. While still wet I pick up the tint with the No. 20 flat sable but only from the areas that I plan for the blue sky. When dry, I rewet only the edges of the blue shape at the upper left corner, float the mixture of cobalt blue with a smidgen of phthalo blue with the No. 6 brush, and work my way across the top, following the same procedure for each blue shape. Then for the lower sky I add more phthalo blue to the cobalt blue and dilute the tint still more to let the warm underpainting give the horizon a glow. When completely dry, I lighten the lights on the clouds with a Pink Pearl eraser for greater contrast against the sky. Moving to the background I begin the buttes with alizarin crimson, ultramarine blue, and yellow oxide, using the No. 6 brush. As I move to the foreground I combine the Nos. 6 and the 10 flat sables, still using the same colors.

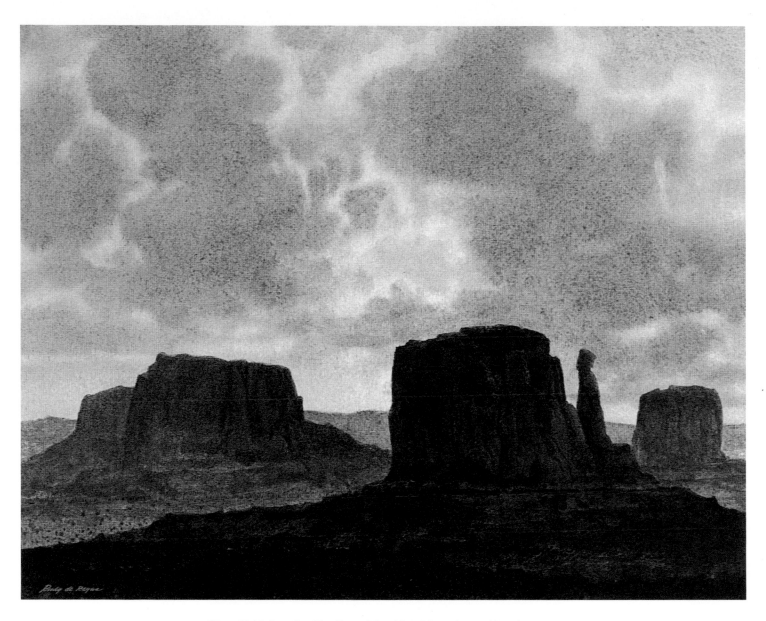

Step 5. Using the No. 5 and the No. 6 brushes with mixtures of alizarin crimson, yellow oxide, cadmium red light, ultramarine blue, Hooker's green, and burnt umber, I deepen the values of the buttes and, consulting the snapshots and the sketch, I render their detail. I'm using the tip of the brushes for the contours and the linear articulations, and then flip them under the palm to rub the side of the sable for the broad passages. And last, I make some minor changes on the clouds with alizarin crimson, yellow oxide, and cobalt blue because there were (check the previous step) too many horizontals hitting the right border of the picture.

12
West Coast Cliffs

Subject. I have mentioned that when painting one must put all the senses to work—not just one's sight. One must feel the wind, the heat or the cold, hear the sound of waves or the rustle of leaves, smell the clean sea air or the fragrance of the woods. All this is to be recalled when working in the studio—especially when using photographic data. So, gather your material and assemble it in a sketch. Naturally you can paint the one I've done but wouldn't it be better to sign your name to a creation of your own?

Brushes. Judging from the price of red sable I've concluded that either the precious little fur-bearing creatures are extinct, or they all went out en masse for a vasectomy. Pity, but thanks to Robert Simmons and the synthetic White Sable we have no cause to despair. I have used here Nos. 3, 5, 6, 7, 8, and 10, plus two flat sables, Nos. 20 and 22, that I now keep in the nethermost subterranean vault.

Other Tools. No need of other tools for this painting.

Palette. I deliberately chose a restricted palette of only naphthol itr crimson (darker than naphthol crimson), yellow oxide, and ultramarine blue—plus touches of phthalo blue to demonstrate that with few exceptions, richer and more vibrant color can be obtained by variegating (dropping color into a wet wash) and glazing the three primaries than by mixing more colors. I introduced white only for the finish.

Painting Surface. This painting could have been done on any watercolor paper. I've chosen a No. 80 Bainbridge cold pressed board mainly because I'd like to encourage the young artist to experiment with as many different surfaces as possible. There's no other way to discover their advantages as well as their limitations.

Medium. Keep in mind that when working in acrylic you can glaze to your heart's content without fear of disturbing the underlying color. The variety of nuances obtainable by glazing one film over another is infinite, and there lies the medium's greatest charm.

Painting Tips. The accomplished artist will forgive me if I repeat to the student that the tilt of the support, when applying large washes, is of paramount importance. If it remains almost level the washes will not flow in the desired direction. Practice flat, graded, and variegated washes on dry and wet scrap paper or board.

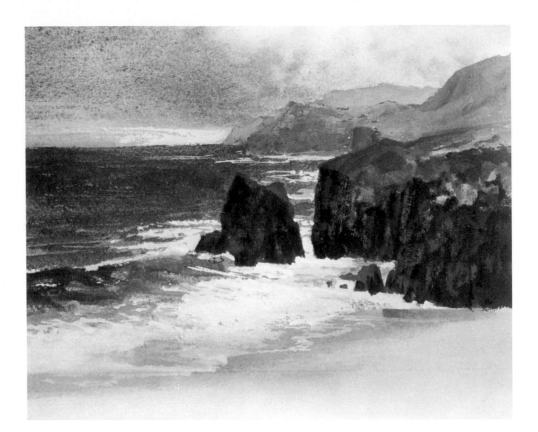

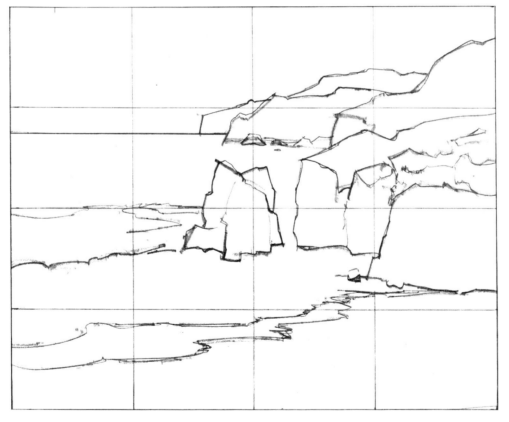

Sketch. (Top) This sketch, like the one in Demonstration 11, came about because friends in California sent me some snapshots. If I stress the point it's only that it may not have occurred to you to ask friends and relations for similar reference material. There's a wealth of stuff out there, and I'm sure that at the drop of a postcard or the ring of a phone you can get all you need and more. I combined three snapshots of the cliffs and then invented the sky to suit the shapes I had already established. It measures 6½″ x 7¾″ (16.5 cm x 20 cm), the color was from the Pelikan box, the brush a No. 6 White Sable, and the paper a scrap of 72 pound Fabriano Imperial handmade rough.

Step 1. (Above) Sometimes I trace the cloud formations in a drawing, but I do this only when I want the exact shapes I've painted on the sketch. When working in the transparent technique I'd rather take advantage of the spontaneous effects without the restrictions of established boundaries. Though I still try to retain the character of whatever clouds I may have done on the sketch. As you notice, I enlarge quite faithfully the rest of the drawing, using the squaring-up method.

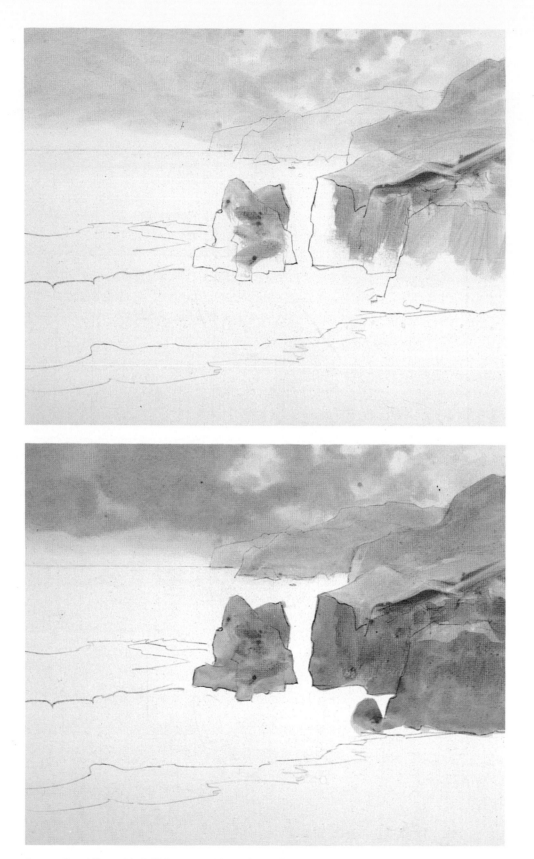

Step 2. (Top) I wet the entire 11″ x 13⅜″ (28 cm x 34 cm) picture area with the No. 22 flat sable. Then, holding the board slanted a bit toward me, I take the No. 20 flat with yellow oxide and begin to paint the clouds, spreading the color into shapes that closely resemble those on the sketch. I've erased (before wetting the paper) the traced lines in the distance with a kneaded eraser. After the paper dries, I continue using the same brush and the same color to do the parts of the cliffs that require the warm underpainting.

Step 3. (Above) First I rewet the sky area with the No. 10 White Sable and then with the same brush I dip into the naphthol itr crimson and ultramarine blue, mix, but not too thoroughly, on the butcher's tray the color that I float over the cloud shapes. I vary the amounts of blue or crimson so that when combined with the yellow underneath, I get the nuances I want. As I work I try not to slap the brush to avoid splattering paint where I don't want it.

Then I move to the cliffs and give them washes in varying degrees of dilution, but still using the same two colors.

Step 4. With the No. 7 brush I lay in the initial color of the sea, mixing on the tray naphthol itr crimson, yellow oxide, and phthalo blue. Notice that in the beginning stages I've used mixtures of red and blue over yellow, and now all three colors together, letting the blue dominate, but tempered with the other two. With the same colors I paint the sand but let the yellow oxide dominate. Still working in transparent acrylic, I leave the whites untouched. At this stage I'm aiming for the middle values of the seascape; later I can place the deepest darks where I want them. I've planned to carry this picture as far as I can with transparent color and then give it the last touches with opaque. So let's continue the washes and glazes.

Step 5. After rewetting the sky, I give it additional glazes of naphthol itr crimson, yellow oxide, and ultramarine blue, using the No. 10 brush. With warm and cool mixtures of the same colors I move to the cliffs, switching to No. 5 and No. 6 brushes, and bring them closer to completion. I'm mixing on the tray, adjusting color values as well as the tonal harmony, using more pigment and less water as I come forward to the darkest, changing to the No. 7 brush. I darken the sea next, adding phthalo blue to the 3-color mixtures on the tray. And last, I do the dark wet sand after wetting the near edge to make it soft.

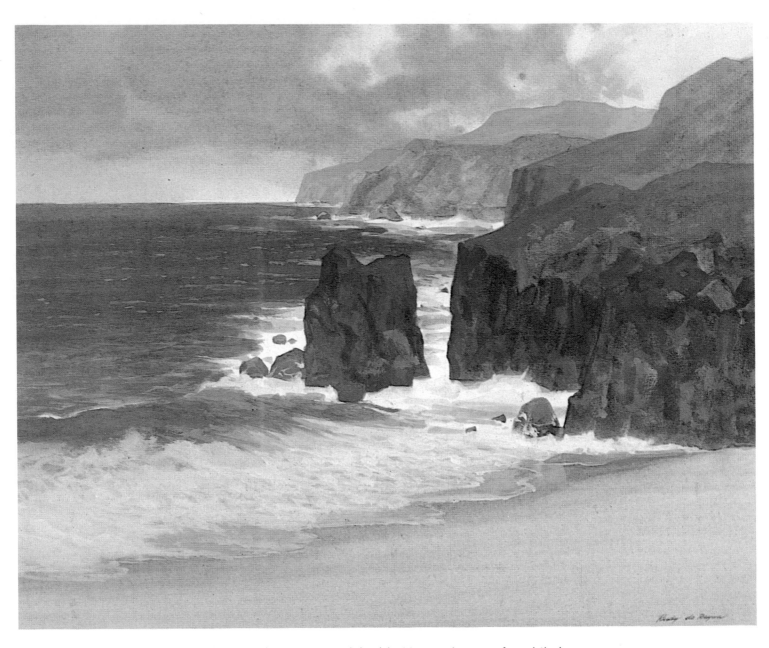

Step 6. Now as planned, I add white to mixtures of naphthol itr crimson, yellow oxide, ultramarine blue, and phthalo blue. First the sea, beginning at the horizon and working my way down I deepen the color and subdue the swells, with the No. 3 brush. Then I switch to the No. 5 brush to do the white foam of the spent wave. I'm loading the whites thickly, but with whispers of alizarin crimson, yellow, and blue. I do the cliffs next with Nos. 5 and 6 brushes, subduing, emphasizing, modifying, but especially darkening and cooling their faces. I also add some smaller rocks. The last touches are the white caps on the sea which I lay in with a No. 3 brush.

13
Waiting for Spring

Subject. Every day on my way up to the studio in the barn, I would glance at the motorcycles in their spectral sheets. Thoughts of them would haunt me while I was engaged in other work. When this happens there's nothing to do but paint the blasted things and be rid of them. It turned out to be a rather complicated piece of work but it's not as difficult as it appears—you'll see when you do it.

Brushes. Once upon a time there was a chap who went shopping for tree brushes. When informed by the clerk (kind bloke that he was and not wishing to offend) that he'd just sold the last one, the fellow said, "Well, I hope you're not out of water brushes because I'm having a hell of a time painting a pond." Silly? Yes and no. There are certain brushes better suited to do a particular job, and that's the reason I used this variety: No. 4 flat nylon, ⅝" (2 cm) flat sable, Nos. 1 and 10 pointed red sables, and White Sables Nos. 3, 6, and 7.

Other Tools. The other tools necessary were: black drawing ink, a Gillott pen point No. 404, a graphite stick, a razor blade, and a sponge.

Palette. For this painting I leaned heavily on the earth colors: burnt umber, raw umber, raw sienna, burnt sienna, sepia, plus ivory black and Davy's gray—all Winsor & Newton's watercolors. They were relieved and heightened by alizarin crimson, cadmium scarlet, cadmium red, cadmium yellow, cadmium yellow pale, French ultramarine blue, and white.

Painting Surface. I chose Crescent watercolor board No. 112 because its rough surface was ideal for rendering the old walls and barn floor, and it also allowed me to do the most minute detail on the motorcycles.

Medium. When a painting requires two or even more media to accomplish the desired results, there should be no hesitation in making the most of what each has to offer. I have used transparent and opaque watercolors because there were articulations that one could do better than the other.

Painting Tips. Since you have a reverence for the truth and beauty of things (or you wouldn't be studying this book), then, by George, read nature and man-made things as they are, imbue them with your feeling, and filter them through your vision. But first, you must love the subject. If this one isn't appealing, find something similar and let's get to work.

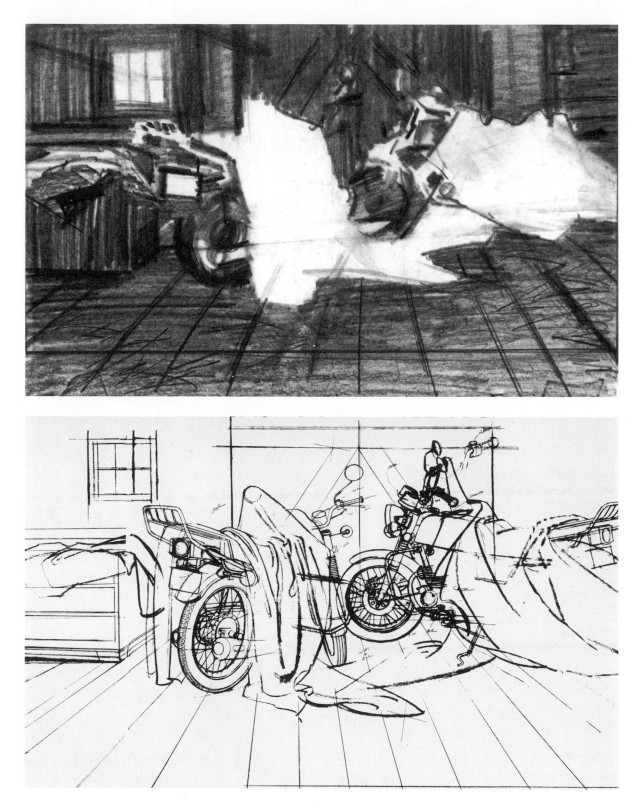

Sketch. (Top) I rarely do a black-and-white sketch, because I depend on this initial stage to solve problems of color and composition and at times even those concerning texture, but this sketch is certainly a rough scribble—with a 314 "Draughting" pencil on tracing paper. But since I'm primarily interested in the placement and design of the white shapes, I had no need to go any further. Besides I can consult the models on the ground floor of the barn for all the color and detail the painting requires.

Step 1. (Above) I enlarge the general shapes in the sketch, only for placement in the enlarged drawing because there's no detail at all yet. Then I go downstairs and, with a grade 2 office pencil and the tracing pad balanced on my lap, I begin the accurate drawing I need before tracing it down to the illustration board. First, I slip the enlarged shapes under a new sheet and then I begin with the motorcycle on the left. I move to the right motorcycle and try to pin down every nut and bolt on the blooming thing. I may have to refer to the subject again, but the information I've got so far will suffice for me to get started.

Step 2. (Top) I have a "brother of the brush" who, after tracing a drawing, makes a groove with a hard pencil on important details so they won't get lost as he paints. This is a very clever idea for advertising art, when the original is not seen by the public, but for a painting I prefer the method I learned from my friend Peter Helck, and that is to ink in with a pen and India ink any part of a drawing that must be preserved as the painting progresses. Therefore, with a rigid Gillott No. 404 pen point I secure the line drawing of the motorcycles and the floor boards.

Step 3. (Above) After going downstairs for another peek, I begin the first indication of the wall by using the No. 6 White Sable and dipping into Davy's gray, sepia, burnt umber, and black. At this stage I'm not so much interested in correct values as I am in establishing the character of the old wall, by working quick strokes with the scantily charged brush. I'm using the point for linear details and the side of the stock, taking advantage of the rough paper to get the texture of the boards. The timbers flanking the doors are painted white and I decide to show their peeling paint; if these white notes interfere with the central whites of the sheets I can easily darken them to the value of the wall.

Step 4. (Top) I'm eager to cover all the whites except those that triggered off the design of the picture. To render the floor, I pick up the No. 10 brush and dip into the puddle used for the wall but now add more Davy's gray and black. I work with a fully loaded brush and use strokes slow enough to cover the rough paper completely. The walls are rough but the floor has been polished by a century of traffic of four- and two-legged creatures. Then I add more water to the puddle in the tray and give the chest its first flat wash. The whites on each side of the doors must go because they conflict with the white shapes on the bikes.

Step 5. (Above) Still using the No. 10 brush and dipping into the original puddle of Davy's gray, sepia, burnt umber, and ivory black, I "kill" the white verticals flanking the doors. Even though I'm anxious to get to the bikes, I must first render the folds on the sheets. I wet the shapes and with the same brush and colors I do the folds wet-in-wet, resting my hand on a mahlstick. Then I darken the chest and give the cloth on it a light wash. Moving back to the wall, I deepen it and throw a diagonal shadow at the upper right corner. Noticing the floor is too smooth and even, I give it a few swipes with a damp sponge.

Step 6. (Top) I begin the bikes, adding cadmium yellow, yellow deep, cadmium scarlet, alizarin crimson, and French ultramarine blue to the existing palette. Notice I've removed the color on the mirrors, handle bars, and racks by wetting the shapes with the No. 4 nylon flat, letting the pigment dissolve a moment, and then I pick it up with the edge of a folded paper towel. I do the chrome with ultramarine blue, sepia, and black, mixing on the tray, and striving for the warm and cool nuances of the metal. As I do the tires, I realize I have not drawn the tread. I go below, take a rubbing of the rear tire with tracing paper and a graphite stick. Then I draw the cleats in their proper size and perspective on the line drawing, and trace them. Next, using the No. 3 White Sable, I give the reds a thin wash with cadmium red and crimson, and the license plates with cadmium yellow and a whisper of black.

Step 7. (Above) All the whites are still the paper itself. I continue working on the chrome and do the mirrors with the No. 3 brush. Then I warm up the floor and put in a dark diagonal on the lower right as a counter thrust to the one at the upper right, using the No. 10 brush and the ⅝″ (2 cm) flat. The colors for this are cadmium yellow deep, raw umber, alizarin crimson, and black. I also make the chest darker, and after wetting the knobs, I lift the pigment off with a paper towel. I return to the wall and darken the boards round the window so that by contrast the light outdoors appears brighter. Back to the floor, I scratch out the straw with the corner of the razor blade. Move then to the red and amber lights and give them their last touches. Then to the view seen through the window, using the No. 3 brush and alizarin crimson, cadmium yellow deep, and French ultramarine blue.

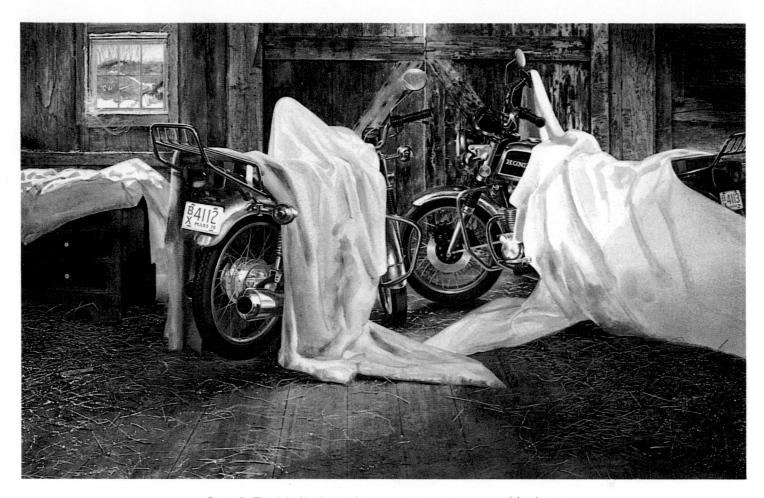

Step 8. For this final step I press some permanent white into a nesting cup and mix a touch of alizarin crimson with it. I render the license plates, using the No. 3 brush. The racks and the last touches on the chrome come next, with the same brush but adding French ultramarine blue, black, and raw umber. Even though the color is now opaque I keep it thin, with just enough covering power to do lights over darks. I follow this up by doing the Honda trademark with the No. 1 sable brush. I go over the inked-in spokes and render their lights and darks by using the ruling method. Then, to unify the straw I sweep and pat the sponge on the floor with whispers of cadmium yellow deep, cadmium scarlet, and a smidgen of white. I add a few more straws with the No. 3 brush and cadmium yellow deep, cadmium yellow pale, and burnt umber. The cobweb on the window was the last touch using the No. 1 brush and white and a touch of raw sienna.

14
Near Mystic

Subject. After the ordeal of the preceding demonstration I think we should relax and do something easy. See how considerate and thoughtful I am! Anyway I hope you didn't skip the last project. You don't have to use motorcycles as the subject but maybe carts, old wagons, or old trucks. I'm only suggesting because choosing subject matter is a most personal affair. But I doubt there's an artist who doesn't enjoy painting rocks—so let's have some fun.

Brushes. Gather the following brushes and put them in a separate pot because you'll need no other for this 10″ x 12″ (25.4 cm x 30.5 cm) painting: No. 22 flat sable, No. 4 bristle bright, Nos. 1, 2, and 7 pointed red sables, and Nos. 3 and 6 pointed White Sables.

Other Tools. Whenever another tool is introduced it should be because it can produce better results than the brush alone. The brushes I used needed no assistance for this job.

Palette. In this demonstration the opaque colors I used were: alizarin crimson, yellow ochre, brilliant yellow, ultramarine blue, and burnt umber. The transparent colors, which I'll mention as we work, were from Grumbacher's

Symphonic set No. 30/17.

Painting Surface. There's something about Fabriano paper that makes it a joy to work on no matter what the subject. It could be because it's handmade and its texture couldn't be more even. I've used here the 140 pound rough.

Medium. I love the compatibility of transparent and opaque watercolor because where one falls short the other one is ready to lend a hand. There is nothing better than transparent watercolor to capture the luminosity of a sky and that's why I use it here. I also find it ideal for the preparatory stages before finishing in opaque.

Painting Tips. Test your color on the margin of the same paper you're using for the painting; tints and shades appear different on different papers—depending on their rag content, their whiteness, and their texture. If you paint, as most of us do, somewhere far from the spot that inspired the painting, you must either do a thorough study on the spot or look to other sources for further information. In this case, requiring more knowledge about the textures, I went out, picked up a few rocks, and brought them back to the studio.

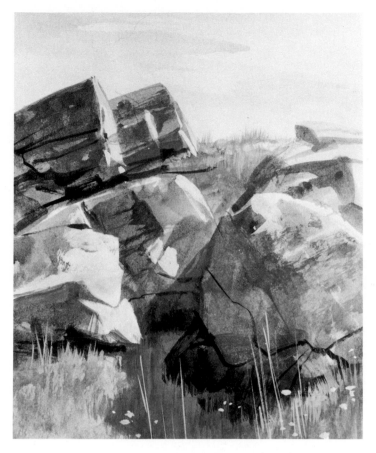

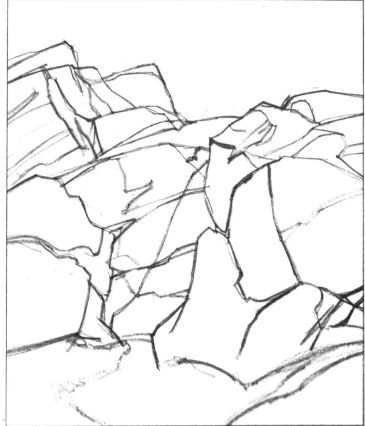

Sketch. I'm sure that for centuries artists have done their sketching while sitting in carts and stagecoaches. I can't imagine chaps like Rubens and Velasquez, Turner, Corot, and Dürer not reaching for a crayon while the postillion watered the horses. Witness Dürer's *Italian Mountains* painted (left unfinished probably because the conveyance had to push on) on his way home from the Grand Tour. I'm not of course placing myself among such august company, but I must mention that I rarely return from a journey without some scribbles on my pad. This one, using the Pelikan box, was sketched from the car, off the Connecticut Turnpike on my way home from New York.

Step 1. How right the bloke was who maintained that it was more difficult to do a drawing in line alone without the assistance of chiaroscuro (light and shade). As you see, without light and shadow this would turn out to be completely illegible. And if it weren't for the sketch above, I doubt I myself could decipher it. But as a working drawing it serves the purpose, and I'll take this chance to reiterate that its only function is to delineate the elements in the picture to show their correct shape, size, and position.

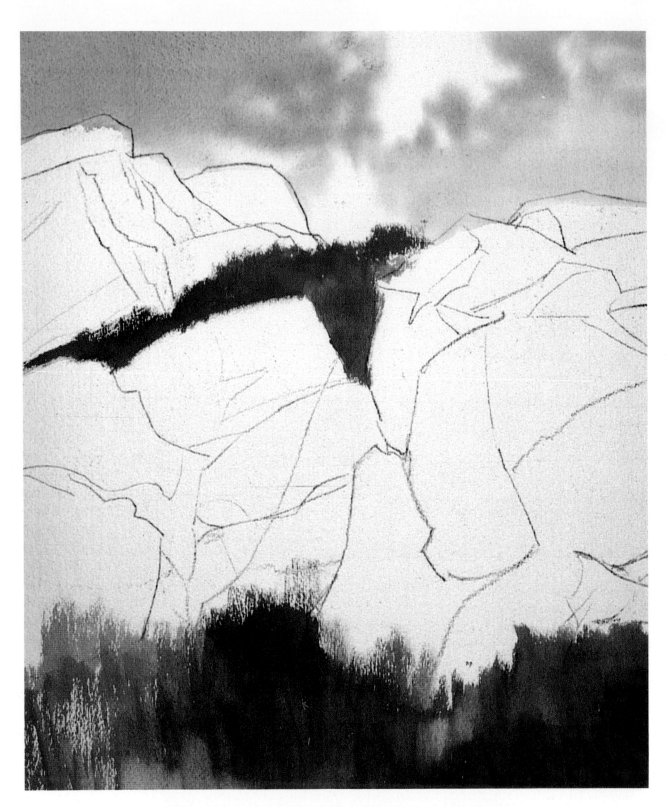

Step 2. First, with the No. 7 pointed sable, I mix on the tray equal parts of blue-green and blue from the Grumbacher Symphonic set and test the tint on the margin of the paper. Then I turn the paper upside down and wet the sky area with the No. 22 flat sable. Turning the paper right side up while still quite wet, I float the color on it with the same brush. I leave the white and almost white shapes as clouds. When the paper dries I place it back on the 35 degree angle of the drawing table. Then I rub the orange on my palette with the wet No. 4 bristle bright and transfer the color to the butcher's tray, rinse the brush and follow the same procedure until I've transferred spots of yellow-orange, red-violet, and violet. Next, dipping into them for tints and shades I scribble the dry grass using the edge of the No. 4 bristle bright in up-and-down strokes.

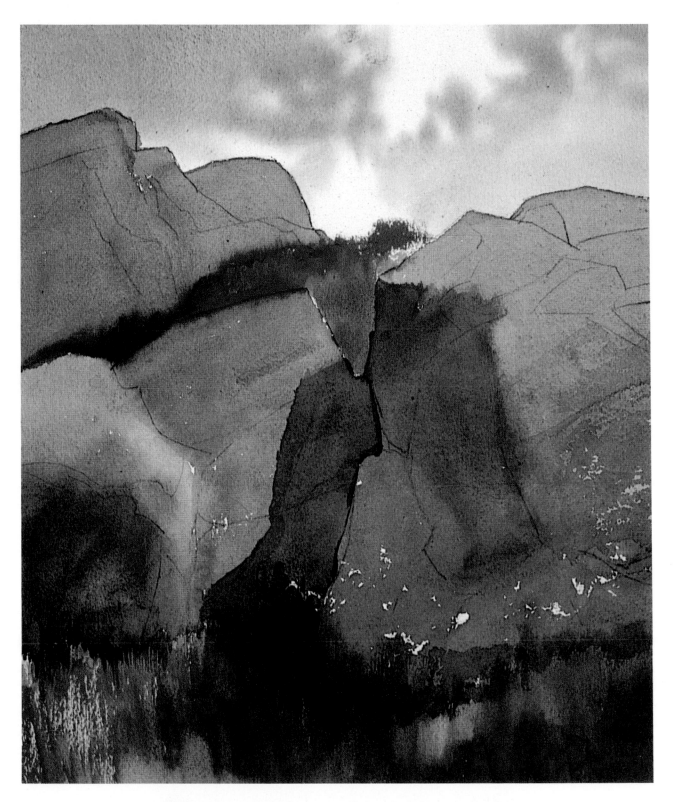

Step 3. Now with the No. 7 brush I lay in the rocks, on dry paper, with mixtures of violet, blue, brown deep, and yellow ochre. As I rub the side of the brush quickly over the rough paper, some white specks are left at the base of the rock on the right. Instead of filling them in I decide to leave them and develop them later as wild daisies. I'm mixing the colors on the tray and letting the warm hues dominate to convey the bright, sunlit day.

Step 4. A quick lay-in of the three main masses—the sky, the rocks, and the grass—is the advantage of using this fast-drying transparent medium. Now I can easily see by comparing one against the other that both the sky and the grass are too intense. The first thing I do is rub the sky with a kneaded eraser; later I will subdue the grass when I paint it with opaque. Then I bring out the form of the rocks with lights and shadows, using the tip and side of a No. 6 White Sable with alizarin crimson, yellow ochre, ultramarine blue, and white.

Step 5. Now I begin to pull the picture together by enlarging the cloud with white and whispers of red, yellow, and blue from the Symphonic, using the No. 6 brush. The rocks come next, I work on both the shadow and the light areas and watch the warm and the cool color values as well as the tonal scheme of the whole picture. I'm still using red, yellow, and blue plus white. I use the No. 1 and the No. 2 brushes for the smaller cracks and the No. 3 for the larger ones. Deciding to keep the white (paper) specks as flowers I work round them as I paint the darker values behind them with the No. 6. Then I add more wild flowers with the No. 1 brush and white. With the side and the point of Nos. 2 and 3 brushes I do the grass adding opaque brilliant yellow to the mixtures on the tray.

15
Twilight

Subject. It was the pervading glow of dusk that impelled me to scribble in pencil—with color notations—the barn and the background that I've used several times in my work. While the impression was still vivid I dashed to the studio and set it down on the Paper King pad, using the Pelikan color box and Nos. 3 and 5 brushes.

Brushes. It is on rare occasions that I use a tiny brush but this time I had to search for my triple zero (000) to do the shingles on the roof. The rest of them, all pointed red sables, were Nos. 1, 2, 3, 5, 7, and 10.

Other Tools. The other tools I found myself reaching for were: a 2H pencil, T-square, fine ball-point pen, plastic triangle, and a synthetic sponge.

Palette. I used the Grumbacher Symphonic set No. 30/17 with 16 pans of color for the transparent passages, and the Pelikan 24 pan set for the opaque articulations. One of the advantages of using sets is that any color you may need is there ready and waiting. Another is that there's not a smidgen of waste. When the cakes dry out between painting sessions one simply rewets them and carries on.

Painting Surface. For a small painting like this I chose a single thickness, cold-pressed Bainbridge No. 80 illustration board.

Medium. The Grumbacher Symphonic watercolor set with its color wheel of primaries, secondaries, and even tertiaries, plus the earth colors and black in the corners is to me a most marvelous arrangement. As for the Pelikan 24 color box I can say it is as complete an assortment of opaques as anyone could wish.

Painting Tips. As with Pelikan opaque colors, so with the Symphonic set: It is better to wet only the colors to be used because repeated wettings of all the pans weakens the binding vehicle and you may find that when glazing one color over another the underlayer will "pick up."

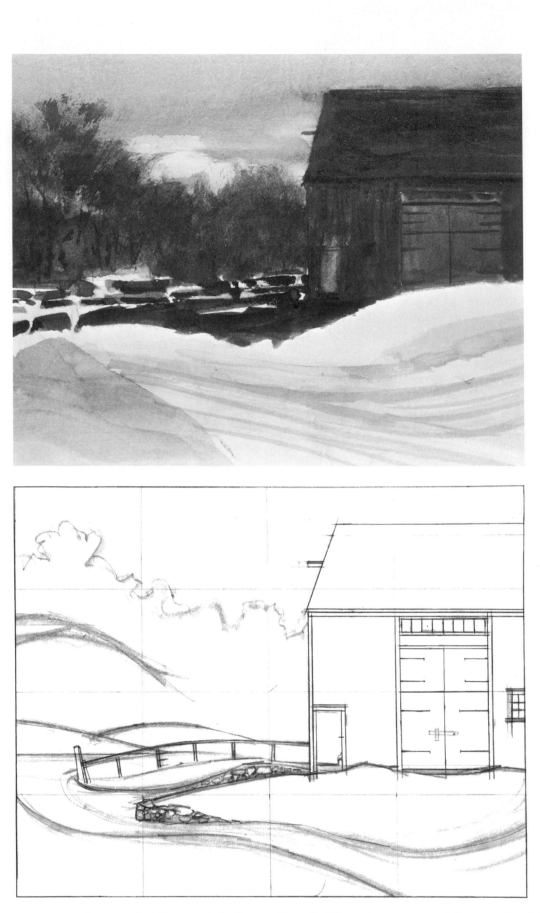

Sketch. (Top) No one can really say what the spark is that kindles a sketch. It could be the nature of the light at a particular time, or the appeal of the elements themselves, or even the mood of the artist on coming upon a scene. For years, almost every day I have been feasting my eyes on the softness of the twilight shown here; the barn is on the grounds of the Skiffe House where I live. But it was only last winter that I finally put it down on paper. The winter passed and it was not until the next autumn that I decided to paint it for this book.

Step 1. (Above) As you see, I've modified the structure of the barn; the proportions are truer in the sketch but I need it taller for the painting. I curved the fence more too, and also the rise in the middle of the road because I want rhythmic and undulating lines to relieve the severity of those on the building. I've done away with the winter scene because I can refer to something that exists but not to the snows of yesteryear. The drawing is 10″ x 12½″ (25.4 cm x 32 cm) on tracing paper, with a grade 2 office pencil.

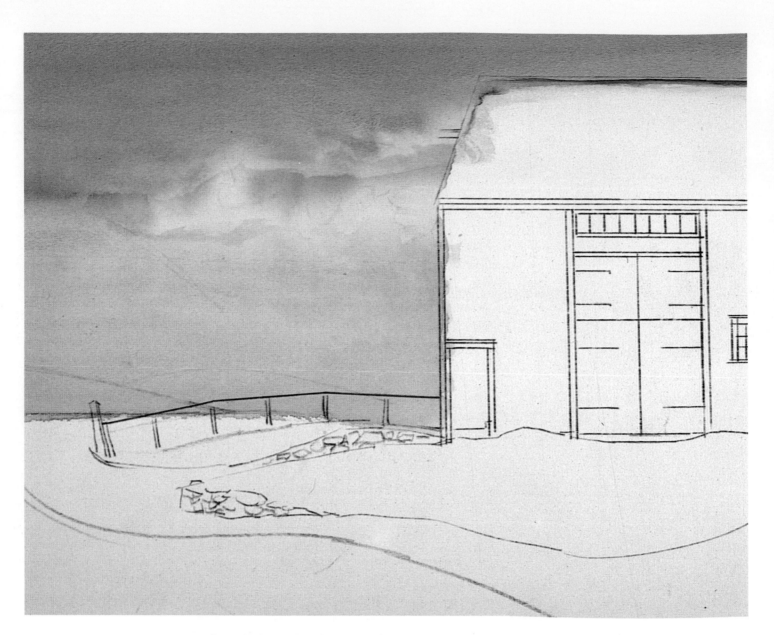

Step 2. I wet the sky area with the No. 10 brush and then with the same brush I moisten the red, yellow ochre, and the blue pans of the Symphonic set. I thin the yellow ochre on the tray and apply it on the wet surface. I follow this up with mixtures of red and blue, leaving the yellow tint untouched. I'm working quickly so I can get the soft edges of the clouds, before the paper dries. The board is almost flat as I study the shapes but I tilt it in the direction I want the wash to flow. When I'm satisfied with the cloud shapes I lay the board flat to dry completely.

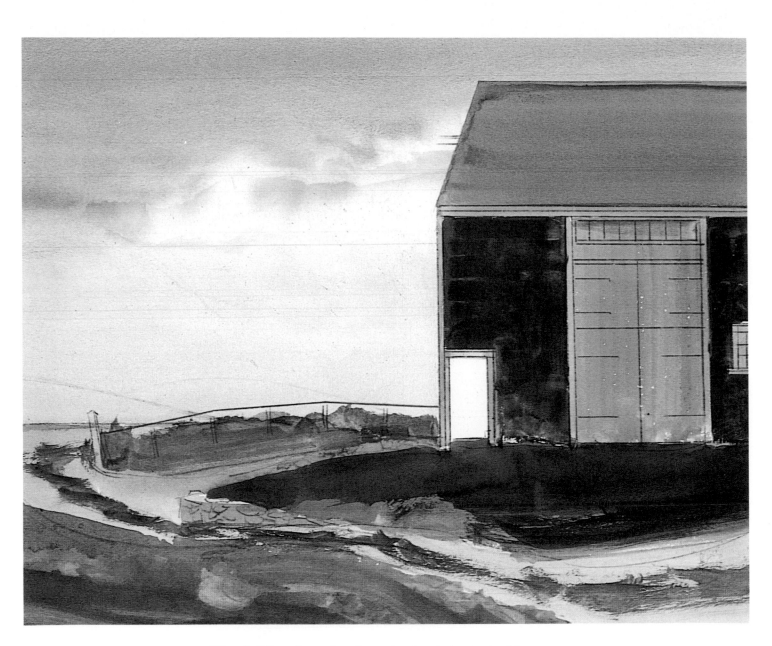

Step 3. When the colors I'm using begin to dry I add a couple of drops of water by squeezing a sponge over them. While doing this I check the sketch to see what other colors I need, and I moisten brown deep, green, and violet. Now with the No. 7 brush I rub the blue, red, and brown deep cakes, dilute them, stir the colors on the butcher's tray, and apply the mixtures to the barn. I vary the amount of water for the light and the dark tones. Then I move to the ground using green, brown deep, red, blue, and violet to lay in the grass and the road with the No. 7 brush and the No. 10 for the larger shapes.

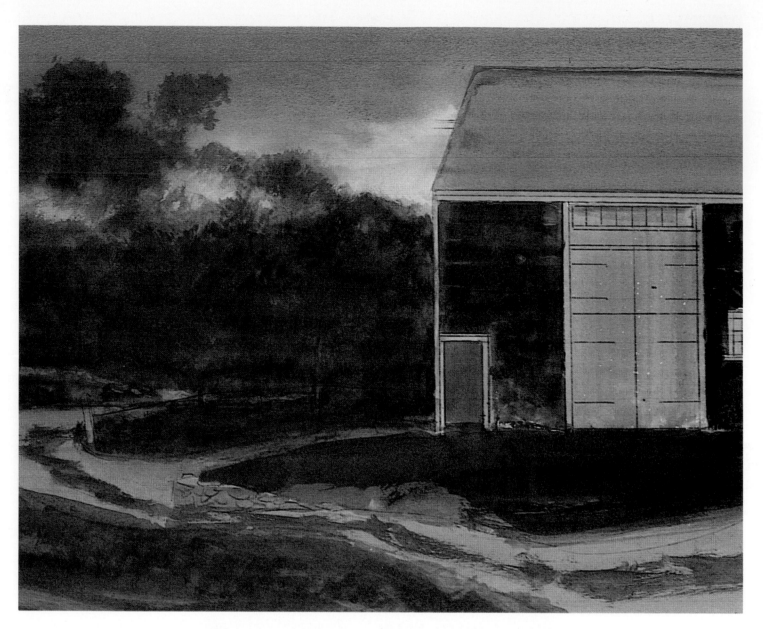

Step 4. I turn the painting upside-down to wet the sky, using the No. 20 flat sable. While still wet I float a mixture of blue, violet, and brown deep to darken it so that the last light on the sky appears brighter. Then referring to a pencil drawing I've just done (the sketch lacked the information), I begin the trees with a lay-in of yellow-green, brown deep, red, yellow ochre, and violet. I use the tip but mostly the side of the No. 5 and the No. 7 brushes. Now I avail myself of the age-old practice of glazing a pervading color over the entire work. In this instance, a thin wash of orange to strengthen the golden glow effect of dusk. I apply the wash in horizontal strokes from border to border with the No. 20 flat.

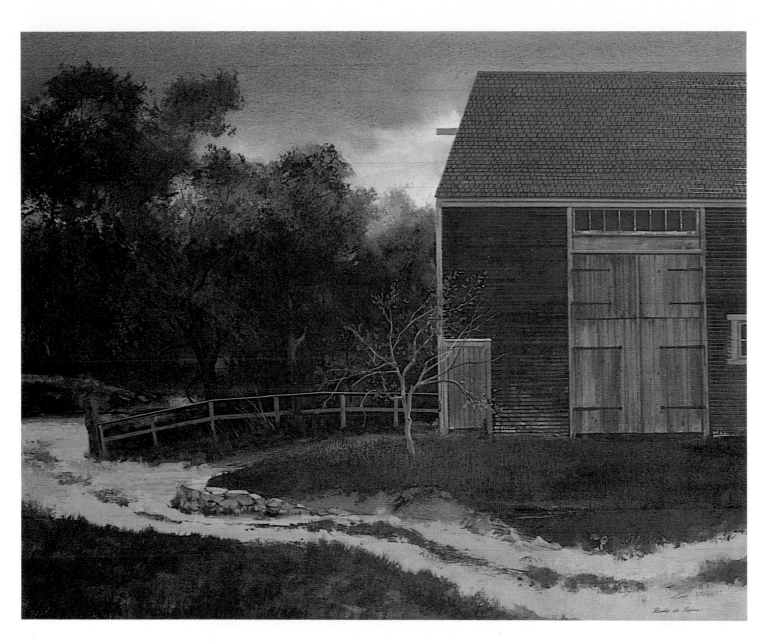

Step 5. Having established the general color and tonal schemes in transparent color, I switch now to the Pelikan opaques and darken the roof with the No. 7 brush, using orange, burnt umber, ultramarine blue, and Chinese white. Then I float a thin wash over the doors, dipping into the roof mixture on the tray but adding a bit of ultramarine blue and a touch of white. Next, with the No. 3 brush I add ultramarine blue and burnt umber to the roof mixture and render the band of window panes above the door and on the right border. Move to the roof again and after drawing the horizontals of the shingles with a T-square and a 2H pencil, I go over them with Payne's gray and burnt umber, using the 000 brush and employing the ruling method. Then I do the vertical shingle separations between the horizontals. Still pursuing the twilight effect, I take the No. 7 brush and darken the wall of the barn with carmine, ultramarine blue, and burnt umber. Then I strengthen the horizontals of the clapboards with a fine black ball point pen, resting against the edge of a plastic triangle. I tackle the drybrushing on the doors, then the hinges, and follow up with the mullions on the windows, using Nos. 1 and 3 brushes, dipping into the colors already on the tray. After transferring blue-green, Payne's gray, violet, vermilion, orange, carmine, Indian yellow, burnt umber, and some Chinese white, I press a synthetic sponge on the colors and then tap and rub them on the trees. Then with the No. 2 brush I do the trunks and branches. I add a small tree as a transition between the vertical of the barn to the movement of the woods. With the No. 1 brush I finish the red door.

16
Nor'easter

Subject. I realize that relatively few of us are given the privilege to live by the sea, or close to it. But I also know that those who visit it on holiday return home with scores of photographs of beaches and rocky shores. Bring them out now and make a sketch so that we can get to work, because if I am to teach you how to paint, we must do it together.

Brushes. I know I could have done this painting with only a sponge, a piece of cheesecloth, a painting knife, and a credit card, but since the conventional painting tool consists of a few hairs at the end of a stick, you should gather your pointed sables Nos. 2, 3, 5, 7, and 9.

Other Tools. No other tools were used because the brushes themselves gave me the effects and textures I needed.

Palette. With the exception of permanent white, the colors are all transparent, by Winsor & Newton. I list them now in case you don't have them all in stock: alizarin crimson, lemon yellow, cadmium yellow, yellow ochre, French ultramarine blue, cerulean blue, Hooker's green dark, and burnt umber.

Painting Surface. I think I should have used a greater variety of papers if only to induce you to try them. But having tried them all after fifty years of painting, it's not surprising that I've settled on half a dozen favorites. Here again I've used d'Arches 140 pound rough surface because it was perfect for the subject.

Medium. As a rule we paint either an aquarelle or an opaque watercolor, but I'd like you to further pursue the technique of laying-in a painting in transparent and then finishing off in opaque. I suggest you use this technique not for correcting transparent passages but as a planned procedure that takes advantage of the virtues of both media.

Painting Tips. Take care when painting rocks that you "feel" (especially when working from snapshots) their bulk, weight, and texture, and even their sharp edges, or they'll come off as papier-mâché fabrications. I alert you to this because at times even the work of established painters is marred by this disfigurement.

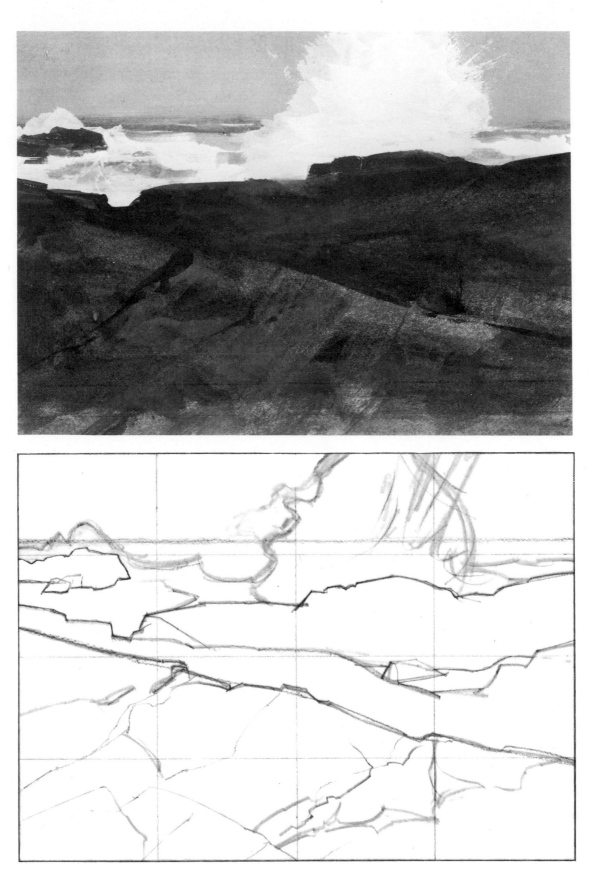

Sketch. (Top) You may have heard the tale that Winslow Homer had a cabin built on wheels to be horse-drawn up and down the rocky coast of Prout's Neck, Maine, so that he could study the sea even in its most savage moods. Lovely legend, but that's all it is. Wouldn't it be marvelous though, to be sheltered while making studies of a stormy sea! The closest we can come to such a convenience is to take photographs and do pencil scribbles as reference material. I've relied on both for this sketch—snaps of a Rhode Island shore on a calm day, and scribbles of an angry sea at Ogunquit.

Step 1. (Above) If there was space I'd certainly show you all the snapshots I have used. The ones I'm using here, for example, show the rocks in horizontal formations. But a horizontal as you know conveys a sense of peace and tranquility, much at odds with the action and the drama that is the keynote of this picture. To achieve this end, I simply slanted the rock formations so that the diagonal can provide the excitement and movement that the situation requires. The point to observe is that photographic data can rarely be used as it is, but should be adapted to fit one purpose.

Step 2. In a white dish I mix about equal amounts of French ultramarine blue and burnt umber, and the same amount of water. Then I wet the sky area with the No. 9 brush. (The picture is 11½″ x 15¾″ (29.3 cm x 40 cm).) Consulting the sketch, I run the wash to the crashing wave and slightly below the horizon line, still using the No. 9 brush. When the wash dries I transfer some of the sky mixture into the tray, add cerulean blue and lemon yellow and with the No. 5 brush I indicate the sea. Next, with the sky mixture I apply a flat wash to the pool in the rocks.

Step 3. For the rocky shore, I squeeze alizarin crimson, burnt umber, French ultramarine blue, and Hooker's green dark into nesting cups. Then mixing on the tray, I apply on the dry surface dark variations of the colors with the No. 9 brush, using the tip for the contours and the side for the masses. As I rub with the side of the brush, holding it under my palm, some white specks are left, and I shall retain them as part of the spray.

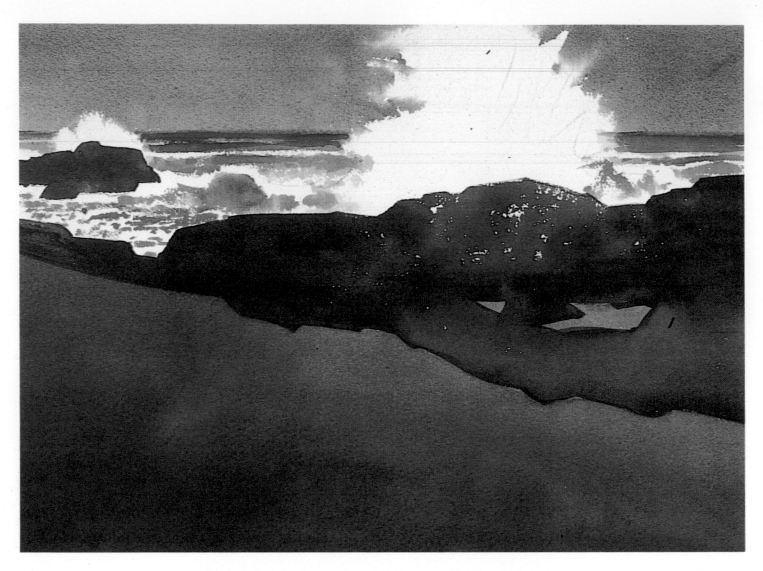

Step 4. I apply the wash to the foreground using the same colors and brush as for the first rock formation. But this time I let the Hooker's green dominate, besides diluting more to make it lighter. Such a fundamental observation smacks a bit of pedantry but I'm addressing myself to all levels of accomplishment and I'm sure the advanced watercolorist will not take offense at such basics directed to the young artist.

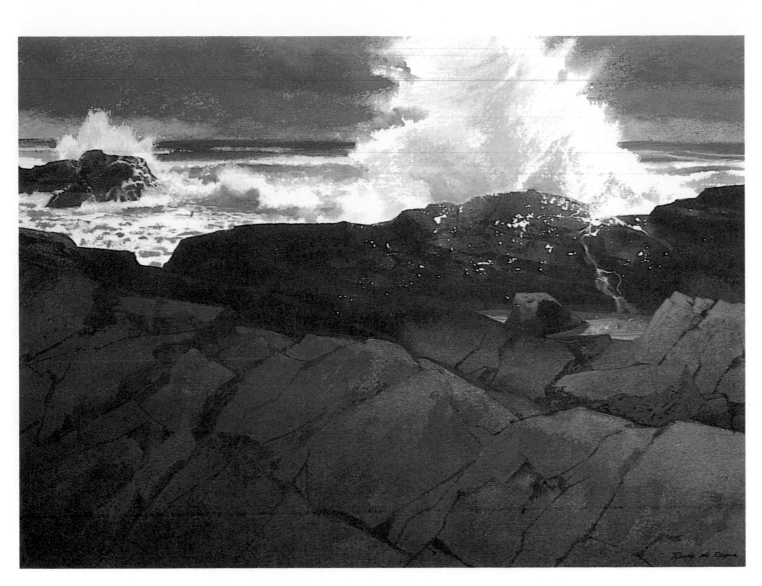

Step 5. I squeeze some permanent white into a nesting cup and begin at the top using the original sky mixture plus cerulean blue, yellow ochre, and the side of the No. 7 brush. Next, the sea with Nos. 2, 3, and 5 brushes dipping into cerulean blue, lemon yellow, alizarin crimson, and white. I rub the side of the brushes to obtain the sparkle of the white dots left by the rough paper. Still using Nos. 2, 3, and 5 brushes I render the farther rocks with mixtures on the tray of crimson, yellow ochre, ultramarine blue, and Hooker's green dark plus white. Moving to the foreground I give it a wash of the four colors just mentioned with the No. 9 brush, making it darker on the left. Then I do the crashing waves with Nos. 3 and 5 and mostly white with touches of yellow ochre, ultramarine blue, Hooker's green, and whispers of alizarin crimson. The warm blotches on the foreground rocks come next using the side of the No. 5 brush.

17

Summer Fruit

Subject. Since time immemorial, fruit has attracted the eye of the artist and it's no different today. What painter indeed can neglect its lovely color and beautiful textures—no matter what the medium to be used. I was eager to begin this painting because the subject lends itself perfectly to the combination of transparent watercolor and acrylic.

Brushes. I don't know who invented the brush, but I imagine it was a chap who tired of painting with a clumsy piece of fur. "By the mighty Magatal," he must have exclaimed. "Why don't I tie some of these hairs on a stick . . . then I can do neater lines!" Bravo, I say. And bless Robert Simmons today for my Nos. 12 and 20 flat red sables, and Nos. 3, 5, and 7 White Sables, plus a No. 3 stippling brush.

Other Tools. To enhance or facilitate the effects achieved here, I used a painting knife, a sponge, and paper towels.

Palette. The Liquitex acrylic colors I used were: naphthol crimson, cadmium red light, yellow medium, yellow oxide, ultramarine blue, phthalo blue, dioxazine purple, raw sienna, burnt umber, ivory black, and titanium white. The transparent colors were from the Grumbacher Symphonic set No. 30/17.

Painting Surface. I've used the Bainbridge No. 80 cold pressed illustration board with underpainted areas of Liquitex gesso. In case you don't have the gesso the titanium white will serve as well.

Medium. At first it didn't seem likely that transparent watercolor and acrylic would be congenial to each other, but since there's only one way to find out, it had to be tried. After all, if Augustus John could rub pastel over an oil painting, what's to prevent us from combining two water-soluble media, right?

Painting Tips. Sometimes even a double thick board will bend as I begin working and to me there's hardly anything more unpleasant. To avoid this I give the back of the board a thin coat of gesso with a 2″ (5.1 cm) brush. The easiest way to remove acrylic color from the butcher's tray is to wet a paper towel, rub it over the dried paint, scoop it up with a painting knife, and then deposit the stuff on the paper towel.

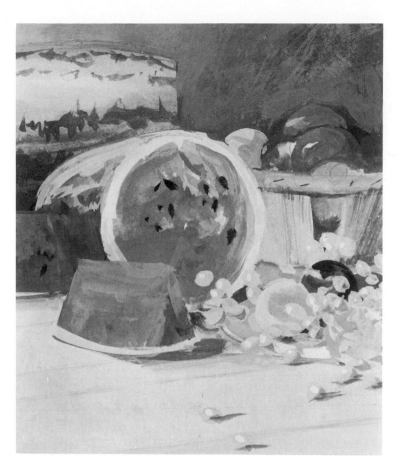

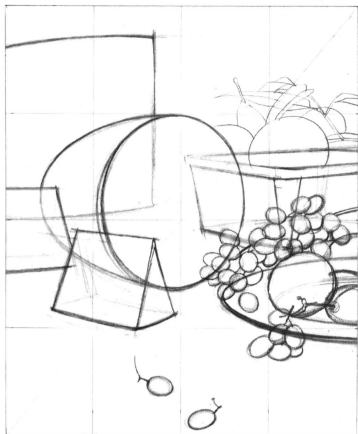

Sketch. Once more I raided the marketplace because I don't want you to ignore the wealth of material to be found there—especially during the summer months when the bins bulge with colorful and beautiful fruits. This sketch was launched after I returned with half a watermelon and the rest of the fruit you see in it. And even though I'm not too keen on red and green complementaries, the subject was so irresistible that I had to have a go at it.

Step 1. Almost two hundred years ago, Ingres, the French painter and teacher said, "Were I to put a placard over my door, and inscribe it: School for Drawing, I'm sure I'd bring forth painters." Just another way of saying if you can draw you can paint. Besides drawing accurately, to paint realistically one must also acquire the aptitude to compose the elements within a given area. My approach to a still life is to put the stuff on a piece of plywood as pleasantly placed as possible and then walk round it to make sure I've not overlooked a still better arrangement. This is the working drawing enlarged to 11½″ x 14″ (29.3 cm x 36 cm) from the 4⅜″ x 5″ (11.2 cm x 13 cm) sketch.

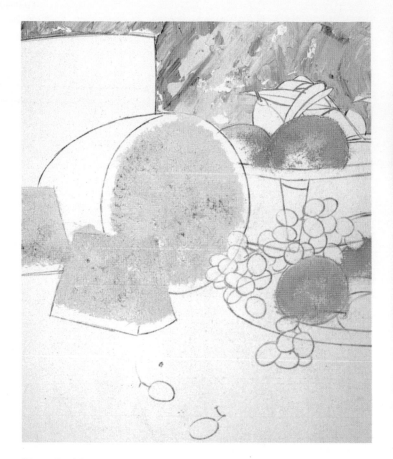 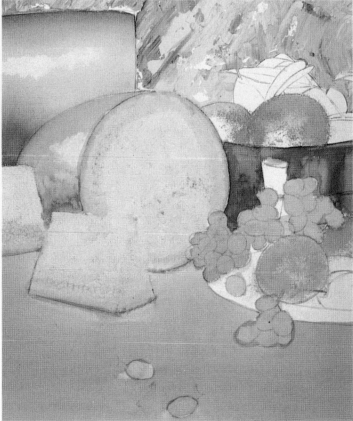

Step 2. After pouring some gesso on the tray, and loosely mixing a bit of phthalo blue and raw sienna, I apply it to the background with the palette knife just as though I were plastering a wall. Then with a synthetic sponge I tap gesso tinted with the blue on the watermelon areas that will be painted red later. For the finer fuzz of the peaches, I tap the No. 3 stippling brush in the gesso on the tray, add a touch of ivory black, and then tap it within the peaches' contours. I've just prepared the groundwork with acrylic for the transparent color coming up.

Step 3. With the No. 12 flat sable I wet the yellow, yellow-green, yellow ochre, blue-green, and red-orange of the Symphonic set, and dilute this greenish tone on the tray. Then with both the No. 12 and the No. 20 flat sables I begin the modeling of the watermelons, blending wet-in-wet. I make the lights lighter by tapping them while still wet with a crumpled paper towel. After adding yellow-orange, brown light, a touch of blue to the greenish puddle on the tray, I apply the initial washes to the crate with the No. 12 flat, and to the table top with the No. 20 flat.

Step 4. I wet the ellipse and the slices of the watermelon with the No. 20. Before they dry I float red, red-orange, and orange from the Symphonic set, while studying the fruit set up in the studio. Moving to the background I scrub blue-violet and brown deep over the gesso with the No. 20. Then I do the peach leaves with the No. 3 brush and red-orange, orange, and yellow-green. The plums come next using the No. 5 brush and violet, blue-violet, and orange. Now checking the peaches on the table, I scumble them with scantily charged Nos. 3, 5, and 7 brushes, using yellow-orange, orange, red, red-violet, and blue-violet—taking advantage of the stippled gray underpainting to strengthen the modeling.

Step 5. I rewet the watermelon slices on the left and in the center with the No. 20 flat sable. Then with the No. 3 and No. 5 brushes and yellow-orange, brown deep, and yellow-green, I deepen the shading and do the stripes. I'm pushing the painting as far as I can in transparent, planning to clean up and finish in opaque acrylic. I render the grain of the plywood next with orange, red-orange, and blue-violet, using the edge of the No. 12 flat and the No. 3 brush. Dipping into the darker puddles, I render the shadows under the watermelon and grapes.

Step 6. Still using transparent color I intensify the reds on the watermelons with red and red-orange. Then I deepen the values on the basket with blue-violet, brown light, and yellow-green using the No. 5 brush. I switch to the No. 3 brush and yellow-green, yellow-orange, and brown light to model the grapes, blending wet-in-wet. This is as far as I'll take the transparent groundwork for the final rendering in acrylic.

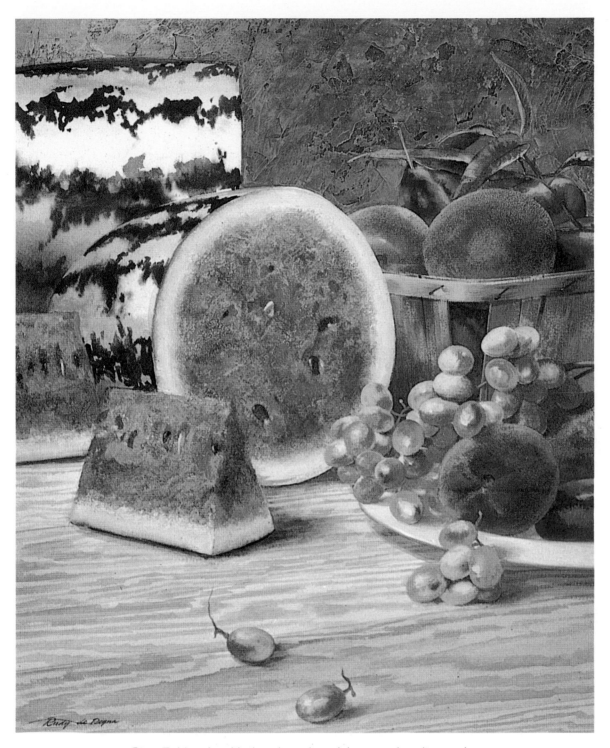

Step 7. I begin with the plums by mixing purple, ultramarine blue, phthalo blue, burnt umber, and white, and use the No. 3 brush. To do the peaches, I scumble rather thick paint with Nos. 3 and 5 brushes using yellow oxide, yellow medium, cadmium red light, alizarin crimson, ultramarine blue, and white. Adding purple to the peach colors I do the leaves, painting a new one to improve the silhouette. With the same brushes I finish the basket using burnt umber, yellow oxide, yellow medium, and white. I go over the watermelon reds with naphthol crimson, cadmium red light, purple, and white—and then the seeds with burnt umber, ultramarine blue, yellow oxide, and white. The rinds come next using white, yellow medium, yellow oxide, and a whisper of phthalo blue. Following this, I render the final details on the grapes with white, yellow medium, yellow oxide, ultramarine blue, phthalo blue, and alizarin crimson. And last, I lighten the upper left corner with alizarin crimson, yellow oxide, ultramarine blue, burnt umber, and white; and then I do the shadow under the plate with the same colors.

18

Bonnie Lassie

Subject. Old boats abound in my area but the boat I wanted was not to be found. So off I went to Rhode Island, only to return with sketches of everything but boats. The following day, on my way to the fish market on the Cape Cod Canal I was struck by a kind Providence because there it was—my boat! The moral is obvious: Look in your own boatyard first.

Other Tools. Besides a synthetic sponge and paper towels, perhaps I should mention the HB drawing pencil that I used for the nail-heads on the patches—just in case you don't have one.

Palette. "All painting worth its oil must rest on good color." Thus spake Delacroix, while Ingres meanwhile maintained that color was only an embellishment to good drawing. When doctors disagree, what are we to do but follow our own instincts and trust that we've chosen well. For the transparent colors, I selected alizarin crimson, yellow ochre, French ultramarine blue, cobalt blue, cerulean blue,

and Hooker's green dark. For the acrylic: naphthol itr crimson, yellow oxide, ultramarine blue, Hooker's green, cobalt blue, burnt umber, and titanium white. With all these colors I endeavored to get good color.

Painting Surface. The No. 112 Crescent rough illustration board is the support I used because its surface is right for the rocks and the rendering of peeling paint that figure so prominently in the picture.

Medium. Because I switched from transparent to acrylic and back to transparent and then finished in acrylic, I thought it best to use two butcher's trays. In case you have only one, a white dinner plate will do nicely for the Winsor & Newton watercolors.

Painting Tips. Remember to separate the brushes used in transparent color from those used for acrylic. And be sure to wash the latter with mild soap and warm water when the painting session is over.

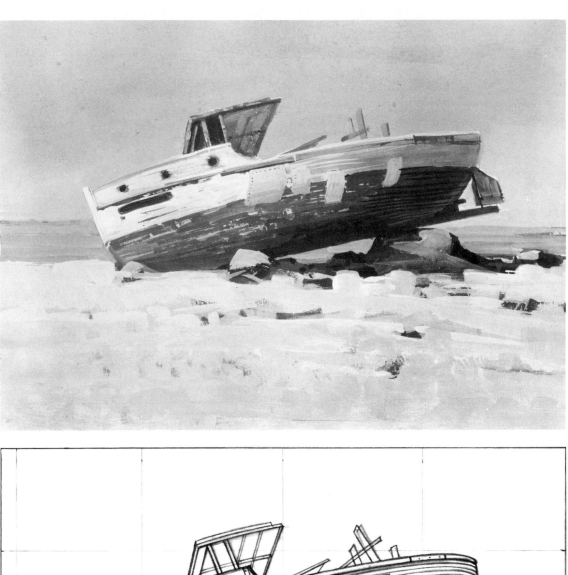

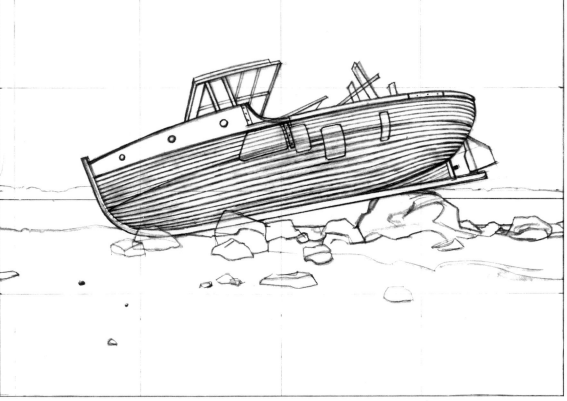

Sketch. (Top) Chances are that old boats are not to be found where you live. All right, not to worry. Find an old shack—peeling paint, rusty tin patches, slanting off the vertical, broken windows—you know, the sort of thing that is magnificent and yet pitiful in its ruin. "There's nothing more pathetic to behold than the wreck of a man," said Goethe. The same compassion fills my soul and I'm moved to paint when coming upon anything old—except when I look in the mirror, and I wonder why. At any rate, here it is on the Paper King pad, using color from the Pelikan box.

Step 1. (Above) This is the enlargement on tracing paper from the sketch I did from the car at the Cape Cod Canal. The study being the only source of reference I have for the boat I was careful to pin down all significant detail as precisely as possible. As for the ground and background, I've done it so often I had no trouble inventing it to suit this particular job.

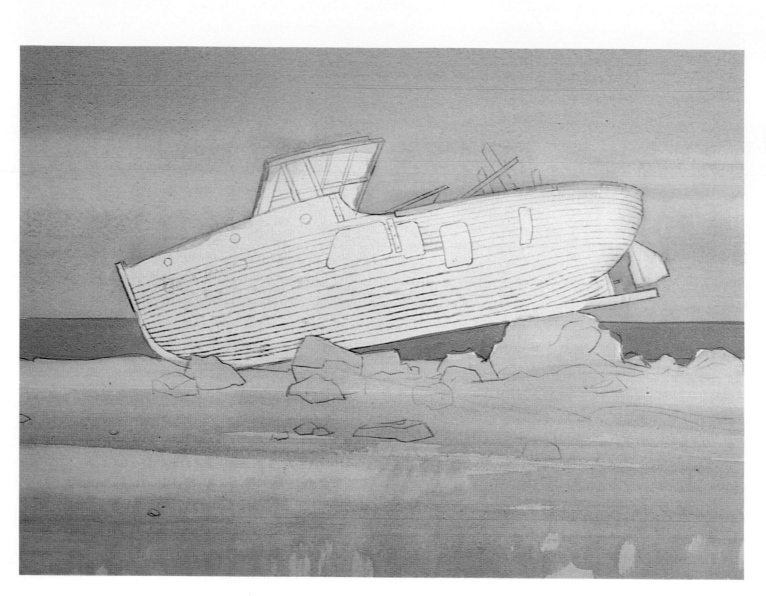

Step 2. Beginning with transparent watercolor I squeeze cerulean blue, yellow ochre, and alizarin crimson into nesting cups. Then, mixing and diluting the colors on the tray with the No. 9 brush, I apply it to the sky in horizontal strokes. While still wet I wipe out the light streaks with a crumpled paper towel. I do the water next using the same brush with French ultramarine blue and cerulean blue. Then to render the ground, I dip into the sky puddle on the tray, add more yellow ochre and alizarin crimson, and dilute it to keep it about the same value as the sky. Before it has a chance to dry, I tap a damp sponge across the picture to get the horizontal streaks.

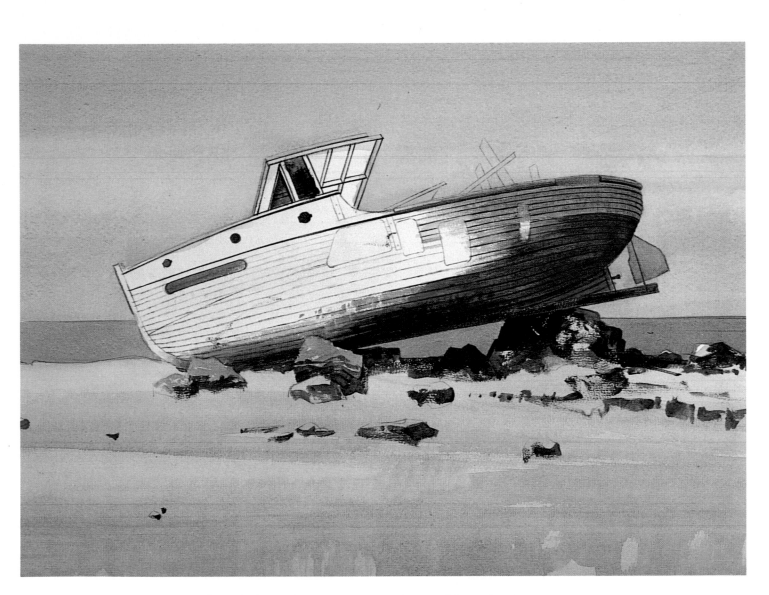

Step 3. I put the transparent palette aside and using another, I press naphthol itr crimson (darker than naphthol crimson), ultramarine blue, and Hooker's green—again into nesting cups. With the No. 2 brush I dip into all three colors and mix on the tray the dark color that I need to secure the drawing of the boat. I do the rocks next by adding yellow oxide to the three colors mentioned, using the tip and the side of the No. 5 brush. Then I give the stern (the rear end of a boat) a wash letting the warm colors dominate. I also do the board for the name to be lettered later.

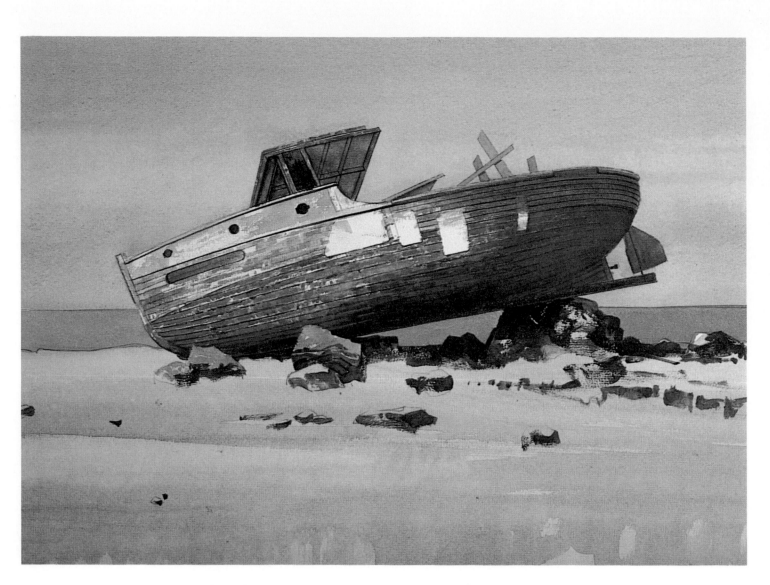

Step 4. After moistening the acrylic color again and stacking up the nesting cups, I wash the tray before putting it away, and replace it with the transparent color palette. I begin at the waterline on the hull (frame of the boat) and work my way down with a mixture of alizarin crimson, yellow ochre, and cobalt blue, using the tip and side of Nos. 2 and 3 brushes, and taking care to leave specks of white and parts of the warm underpainting on the stern. Still skirting the patches above the waterline, I render the white part of the hull with alizarin crimson, yellow ochre, French ultramarine blue, and Hooker's green dark. I do the overhead next with Nos. 3 and 5, using alizarin crimson, cobalt blue, and yellow ochre.

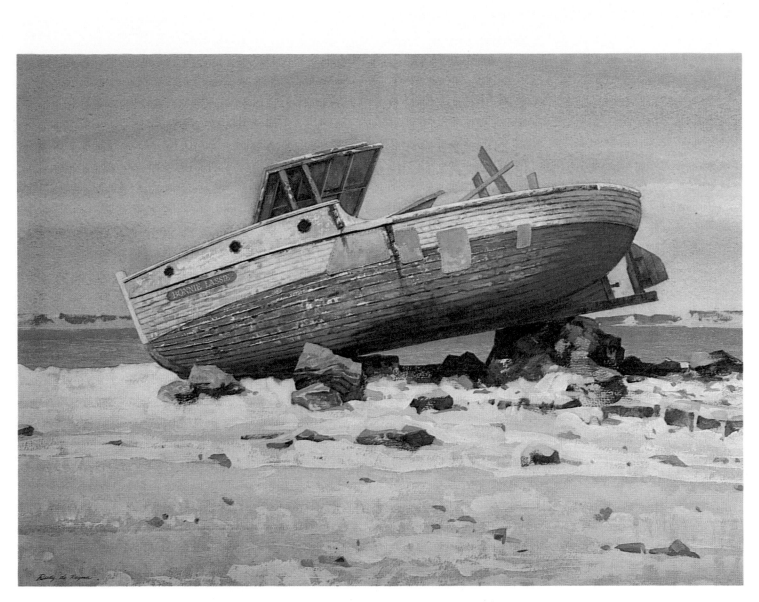

Step 5. Still working from the transparent color palette, I wet the sky area with 1″ (2.5 cm) flat brush and give it a couple of streaks of cerulean blue. After diluting the cerulean puddle for the sky, I apply a thin flat wash to the ground using the same brush to strengthen the pervading blue color of the picture. Now back to acrylic for the finish in the following sequence: (1) With the No. 2 brush, I dip into alizarin crimson, ultramarine blue, yellow oxide, cobalt blue, and white for the wheelhouse (the pilothouse). (2) With the same brush I add burnt umber to the four colors mentioned and do the weathered boards showing above the gunwale (the upper side). (3) I render the white top of the hull with combinations of the same colors but letting white and yellow oxide dominate. (4) I letter the name on the bow (the front) with an 0 brush. (5) Using cobalt blue, yellow oxide, and white, and Nos. 3 and 5 brushes, I paint in the distant dunes. (6) The inlet next with cobalt blue, alizarin crimson, and white. (7) The foreground with thick white and spot of yellow oxide, using the side of the No. 5 brush and leaving parts of the underpainting showing through. (8) I add more rocks with the same palette. (9) Last I do the patches with alizarin crimson, yellow oxide, ultramarine blue, and white—the rusty stains with alizarin crimson and yellow oxide, and the nail heads on the patches with the HB pencil.

19
West Wind

Subject. There are subjects so transitory that they will not wait until it's convenient for us to jot them down. A stormy sky, a fallen tree, a foggy shore, a highway accident, a shipwreck, and things of that nature. When this tree broke I prepared myself to sketch it the moment the wind subsided.

Brushes. Checking my notes on the brushes I used I was surprised to see such a long list: pointed red sables Nos. 1, 6, and 10; White Sables Nos. 2, 3, and 5; a 1″ (2.5 cm) flat watercolor brush, a No. 20 flat sable, and a No. 6 flat bristle bright.

Other Tools. The other tools I used here were a painting knife and a Conté white pencil.

Palette. The Winsor & Newton watercolors: alizarin crimson, yellow ochre, cadmium yellow, French ultramarine blue, and Hooker's green dark. For the acrylic: naphthol itr crimson, yellow oxide, ultramarine blue, Hooker's green, titanium white, cobalt blue, yellow medium, cadmium red light, burnt sienna, cerulean blue, and cadmium orange.

Painting Surface. Since I planned to do the rocks with the painting knife to get their texture, I saw no need to get a support any rougher than the medium tooth of a Bainbridge No. 80.

Medium. I feel certain even in the relatively short time I've been exploring the combination of transparent and acrylic colors that it has endless possibilities. I'll be awfully disappointed if you're not investigating it right along with me. The subject doesn't have to be a fallen tree. Find something similar and follow the procedure I employed.

Painting Tips. Because of other duties you may not be able to devote all your time to painting. No reason to dismay, many artists of renown began by painting in their spare time after attending to the responsibilities of a job. Put your brushes away, if you must, but wherever you may be, paint with your eyes—until you get back to your brushes.

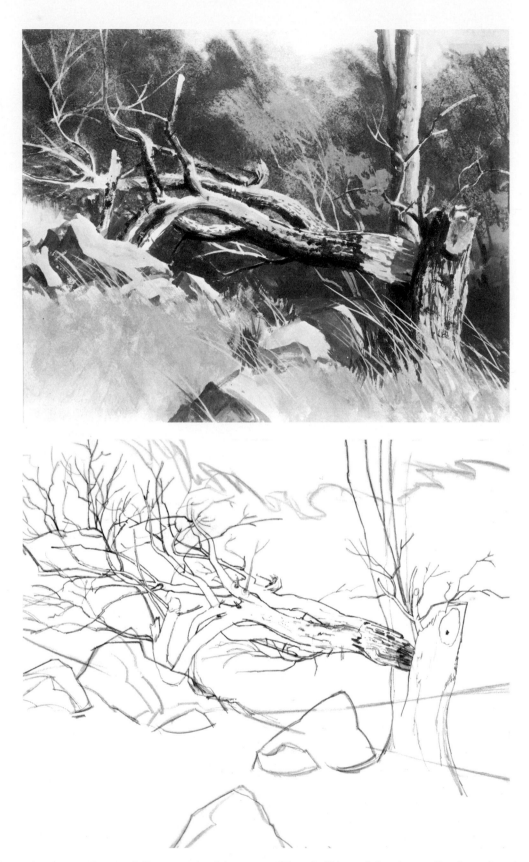

Sketch. (Top) For quite some time a fallen tree had been lying across the road, begging to be painted. "I will," I kept saying, "as soon as I finish the stuff on the board." Then yesterday as I walked by the spot I saw it neatly stacked in two-foot lengths ready to return to ashes. I stood there muttering, "I'm sorry. I'm so sorry." A passerby, thinking I was addressing the wind, gave me a glance, accelerated his pace and quit the scene as fast as his legs and cane could carry him. A few days later the wind got to huffing and puffing and broke a dead tree right on my own grounds and, as if to atone for my negligence of the first, I sketched it quickly.

Step 1. (Above) I enlarge the line drawing to 13¾" x 16½" (35 cm x 42.3 cm) from the 8½" x 10¼" (22 cm x 26 cm) sketch, using the grid method. As usual it is on tracing paper and done with a grade 2 office pencil. I make a few alterations on the tree especially on the trunk still standing because it paralleled the right border too consistently and became monotonous. The top edge of the trees are very simply indicated because I shall use the sketch when I begin to paint them.

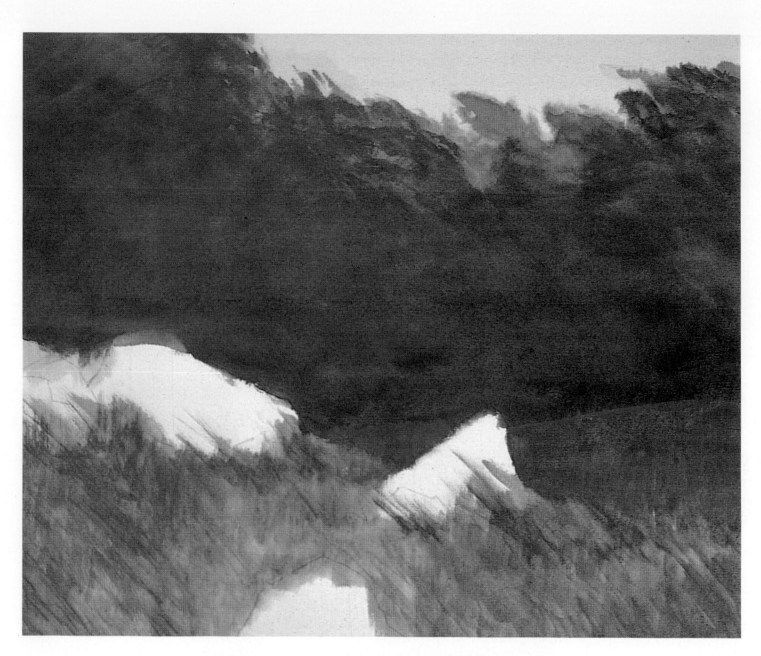

Step 2. After tracing only the slanting lines of the ground and the rocks, I begin with transparent watercolor in this sequence: (1) The sky with the No. 10 brush, using a wash of alizarin crimson, yellow ochre, and cobalt blue. (2) After the sky dries I rewet it with the 1" (2.5 cm) flat brush to get soft edges on the trees that I do next, dipping into the sky mixture and adding French ultramarine blue, cadmium yellow, and Hooker's green dark. The brushes are No. 5 for the top edge and No. 10 for the mass. (3) The middle ground I scribble in using continuous up-and-down strokes with the tip of the No. 6 bristle bright and alizarin crimson, French ultramarine blue, and cadmium yellow. (4) The foreground is done with the same brush but I slant the strokes to the left; I do this also with the trees to suggest the wind is still blowing and use the same colors as in the middle ground but replace the ultramarine blue with cobalt blue.

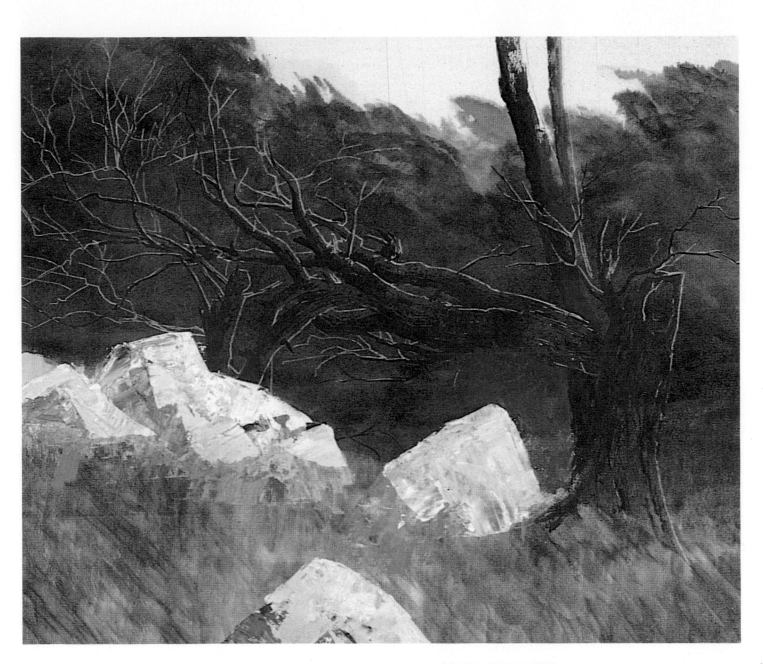

Step 3. I rub a piece of tracing paper with the Conté white pencil, retape the drawing on the board, slip the white transfer paper under it, and trace the tree with a 5H pencil. Then with acrylic I paint the darks on it, using the No. 2 White Sable and naphthol itr crimson, yellow oxide, ultramarine blue and Hooker's green. Next, checking the original and the compositional sketches, I apply the impasto on the rocks with the painting knife using mostly white with touches of alizarin crimson, yellow oxide, and ultramarine blue.

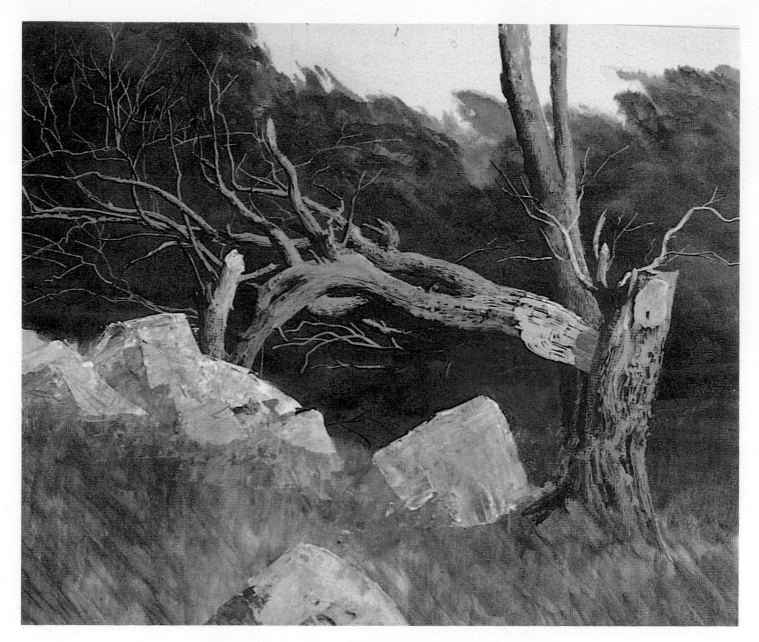

Step 4. With the point and side of Nos. 2 and 3 White Sables, I begin rendering the lights on the tree, letting the dark background show through as an indication of bark and texture. The colors are white, yellow oxide, and cobalt blue. Then I warm up the rocks with a glaze of yellow oxide using the No. 20 flat sable. Compare the rocks in the preceding step and notice that the glaze has bathed them in sunlight. This is something to keep in mind when painting a sunlit scene: warm lights and cool shadows—minding of course warm reflections into the cool shadows when they occur.

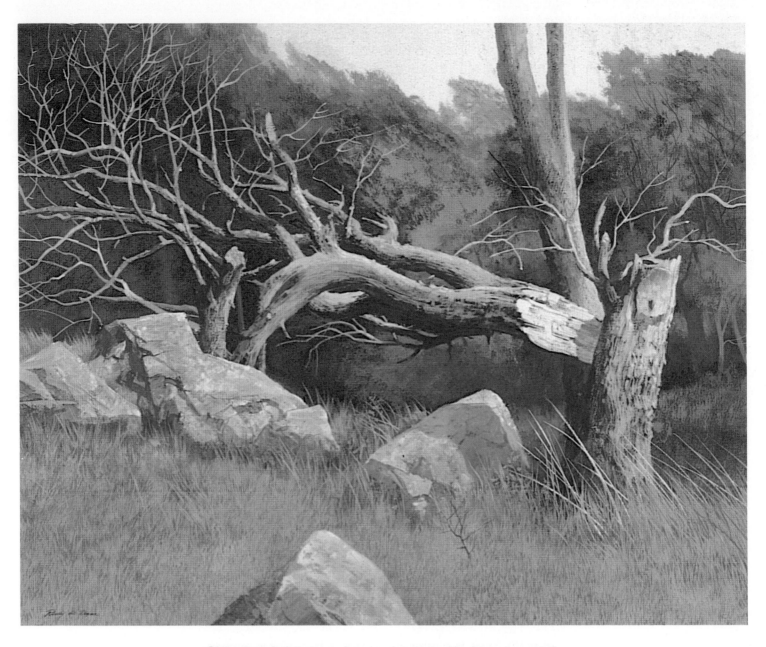

Step 5. I finish branches and twigs with Nos. 1 and 2 brushes, using alizarin crimson, cadmium red light, yellow medium, ultramarine blue, cobalt blue, and Hooker's green. Then over to the trunks to give them the last touches. The details on the rocks come next, using tip and side of the same brushes. Dipping now only into Hooker's green, yellow oxide, cadmium red light, cobalt blue, and white I go over the grass in upward strokes leaning left, with the side of the No. 6 brush held under the palm. Then to describe the blades of grass I go over it with the tip of the No. 2. Back to the background to refine the shapes against the sky and introduce some lighter greens for added interest. I use the No. 5 brush with Hooker's green, yellow oxide, cadmium red light, burnt sienna, and white. While doing this I cover some twigs, but bring them back later. And last I do the trunks and branches on the right edge of the wood.

20
Dune Fence

Subject. After I did the sketch I took a couple of Instamatic snapshots of the fence from different viewpoints. Better to have more reference material than might be needed than to find yourself gnashing your teeth for not bringing enough home. Sketching in a public place will always gather a group around you. If this bothers you (as it does me but I forge ahead anyway) then just take snapshots and do the compositional sketch at home.

Brushes. For this small painting, only 10″ x 12″ (25.4 cm x 30.5 cm) the largest brush I needed for the initial big shapes of the lay-in was a No. 10 pointed red sable. The others were No. 00 and No. 1 red sables and No. 2 and No. 3 White Sables.

Other Tools. I needed nothing but the conventional tools to do this painting.

Palette. For the transparent execution, the colors are all from the Grumbacher Symphonic set No. 30/17, and to give body to the opaques, I used acrylic titanium white.

Painting Surface. The foreign system of education is constant repetition. At the top of our voices we all would sing out in unison the rules of grammar, the mathematical tables, and other nuggets of knowledge. It works, because over half a century later I can tell you verbatim that—*La gramática se divide en cuatro partes que son: Analogía, syntaxis, prosodia, y ortograpfía.* (Grammar is divided into four parts: Analogy, syntax, prosody, and orthography.) And I'm sure you'll find no quarrel with that! So, allow me to repeat: Large paintings on double-ply boards and small paintings on single-ply boards.

Medium. You may very well ask, why acrylic instead of opaque white to give body to the transparent colors as has been the practice for countless years? And I say because we must explore greener pastures. If we let Art continue to feed upon itself, eventually we'll find nothing but fossils on the path we have chosen.

Painting Tips. When referring to snapshots for information there are times when significant detail is so tiny that it must be magnified. One can of course have the snaps enlarged. But to me the most satisfactory way of magnifying is with the "peepers" as I've come to call them. Actually, when you get them you must ask for a Magni-Focuser—a binocular contrivance that adjusts to any size and leaves both hands free to work. I purchased mine at Koenig Art Shop, 166 Fairfield Avenue, Bridgeport, Connecticut.

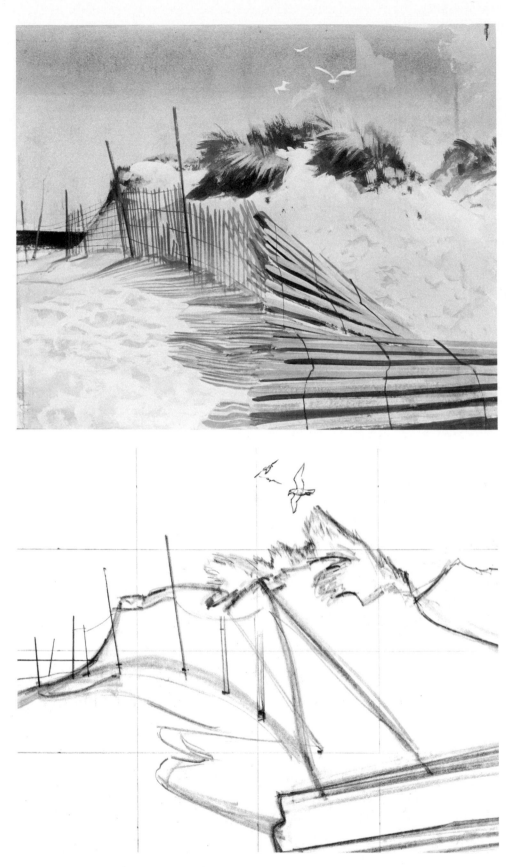

Sketch. (Top) When time permits I drive up and down the Cape for a whiff of fresh air and a spot of tea, and of course to take notes—both mental and graphic—of the lovely stuff that is so plentiful in this area. During one of those excursions I came upon this view at Truro. It was a crisp and sunny day. The gull was on the wing, the wind was on the grass—and the Pelikan box was in the car. What was I to do but go and fetch it, along with the Paper King pad.

Step 1. (Above) I enlarge the drawing from the 6¾″ x 8″ (17.1 cm x 20.3 cm) sketch, using the squaring up method, tracing paper, and the grade 2 office pencil. I like the overall ensemble that beginning at the left expands into the big shape in the foreground, diminishing again as the eye travels back into the distance. And aware of every movement within the area I've chosen, I place the gulls at the peak of the dune slope to carry the eye all the way to the top of the picture. I mention these directional thrusts because I'd like you always to be aware of them when arranging the elements in your own work.

Step 2. After tracing only the horizon line and the contour of the dunes, I moisten the blue in the Symphonic set, dilute it on the tray, add a touch of yellow ochre and a whisper of red to kill the blue's intensity. Then turning the board upside-down and holding it almost flat but slanting toward me I apply the graded wash with the No. 10 brush. Then I turn the picture right side up and dipping into the sky mixture with the same brush, and adding yellow-orange, blue, and red I float the wash over the dune area, diluting it less as I reach the bottom border.

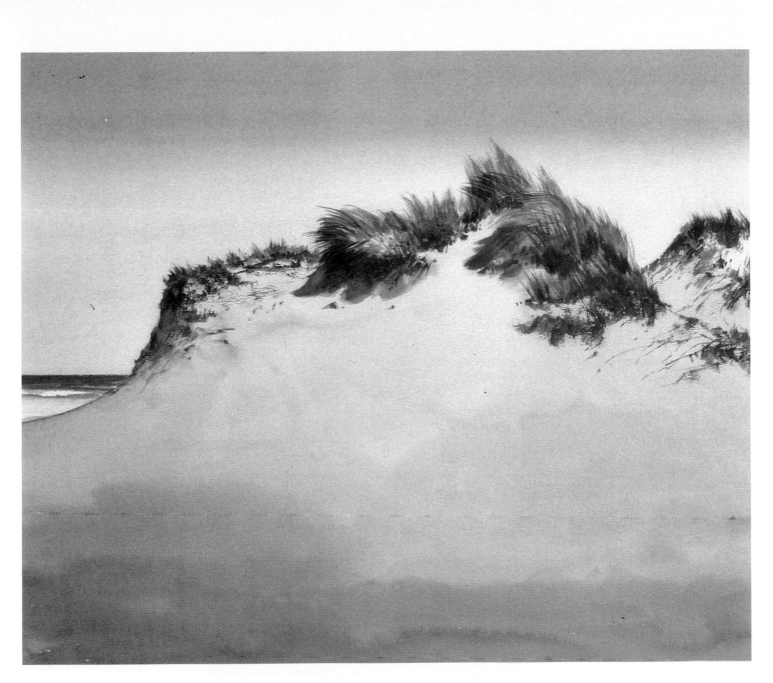

Step 3. I leave the mixtures for the sky and the dunes in the tray, and then in another section (that's why I suggest you get the largest practical size) I mix blue, blue-green, yellow ochre, and a touch of red for the underpainting of the grass and its cast shadows. The strokes for the grass are with the No. 2 from the bottom up and bending left to convey a windy day. The strip of sea comes next with blue and a touch of yellow ochre. Now it's time to introduce the acrylic white.

Step 4. After tracing the shape of the fence, I slip the drawing a bit lower to make the dunes look higher. I work over them with titanium white warmed up with yellow ochre from the Symphonic set, and leave the shape of the fence and its cast shadow untouched. I need these lower values between pickets and shadows or they would jump forward in the picture plane. It's the same principle that demands chinks of blue seen through foliage be darker than the sky itself or they'll jump forward too far. But back to the dunes. While scumbling with the side of the No. 3 brush I take care to leave spots of the darker underpainting as hollows and footprints in the sand. I move up to the grass and go over the first indication with yellow-green, yellow ochre, orange, and titanium white, using the No. 2 brush. Then I begin the fence posts, employing the ruling method, dipping into red, green, yellow ochre, blue, and white, with the same brush.

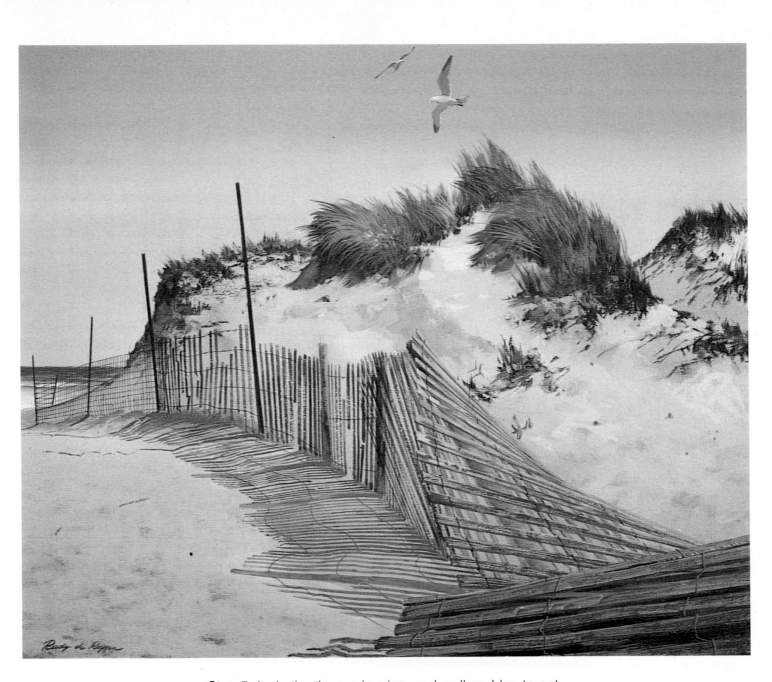

Step 5. I mix the three primaries—red, yellow, blue to get the dark gray I need for the wire portion of the fence, using the No. 1 brush. I do not just dilute black because it's sooty. Using the same brush and the same colors I move to the picket portion of the fence and introduce white acrylic only when I paint lights over darks. I work in fast strokes to take advantage of the tooth of the paper and get the weathered look I want. As I move forward I switch to the No. 2 brush and let the red dominate more. Then I do the cast shadow of the fence with the same brushes and the same three colors. I retape the drawing in position, trace the gulls—two instead of three because they're enough to carry the eye to the top—and render them with No. 1 and No. 00 brushes using red, yellow, blue, and white. Notice that after lowering the fence I had to introduce another clump of grass to relieve the monotony of the parallels between it and the right slope of the dune.

Last Word

The work is done—long live the work! Our job concerning the book is over but painting goes on to the last syllable of time. So now that you have taken the instruction between these covers consider it further as you apply it to your future painting. Adapt it and bend it to your own feelings and your way of thinking, then you can truly say—this is my own. I hardly need to add that your work should be a reflection of yourself. And even though you and I speak the same realistic pictorial language, I'm sure that yours has the intonation and the accent that makes it uniquely yours and no one else's. No artist works in a void. We're all influenced by the art that surrounds us, but it's our privilege to pick and choose and embrace that which is congenial and reject that which is not; not just esthetically but in actual practice. Paint, then observe and feel, and paint again, because—if I may modify a line from Ben Jonson "The good artist is made, as well as born."

Bibliography

Blake, Wendon. *Complete Guide to Acrylic Painting*. New York: Watson-Guptill Publications, 1975.

——. *The Watercolor Painting Book*. New York: Watson-Guptill Publications, 1978; London: Pitman Publishing, 1978.

De Reyna, Rudy. *Creative Painting From Photographs*. New York: Watson-Guptill Publications, 1975; London: Pitman Publishing, 1975.

——. *Magic Realist Landscape Painting*. New York: Watson-Guptill Publications, 1976; London: Pitman Publishing, 1976.

——. *Magic Realist Painting Techniques*. New York: Watson-Guptill Publications, 1973; London: Pitman Publishing, 1973.

——. *Painting in Opaque Watercolor*. New York: Watson-Guptill Publications, 1975.

Guptill, Arthur and Meyer, Susan, E., ed. *Watercolor Painting Step-by-Step*. New York: Watson-Guptill Publications, 1967.

Index

Edited by Donna Wilkinson
Designed by Bob Fillie